The **Kodak** Book of
SCRAPBOOKING
Your Favorite Photos

easy & fun techniques for beautiful scrapbook pages

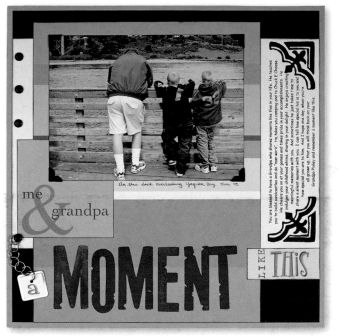

Annette Pixley

Kerry Arquette & Andrea Zocchi

Published by Lark Books
A Division of Sterling Publishing Co., Inc.
New York

Book Concept and Design: Cantata Books Inc. www.cantatabooks.com
Cover Design and layout: Andrea Zocchi
Associate Art Director: Shannon Yokeley
Edited by Kerry Arquette

Library of Congress Cataloging-in-Publication Data

Arquette, Kerry.
 The Kodak book of scrapbooking your favorite photos :
easy & fun techniques for beautiful scrapbook pages / Kerry
Arquette & Andrea Zocchi.-- 1st ed.
 p. cm.
 Includes index.
 ISBN 1-57990-806-3 (pbk.)
 1. Photograph albums. 2. Photographs--Conservation and
restoration. 3. Scrapbooks. I. Zocchi, Andrea. II. Eastman
Kodak Company. III. Title.
TR501.A77 2006
771'.46--dc22
 2005031129

10 9 8 7 6 5 4 3 2 1

First Edition

Published by Lark Books, A Division of Sterling Publishing Co., Inc.
387 Park Avenue South, New York, N.Y. 10016

© 2006, Eastman Kodak Company
Illustrations © Cantata Books Inc.

Distributed in Canada by Sterling Publishing, c/o Canadian Manda Group, 165 Dufferin Street
Toronto, Ontario, Canada M6K 3H6

Distributed in the United Kingdom by GMC Distribution Services,
Castle Place, 166 High Street, Lewes, East Sussex, England BN7 1XU

Distributed in Australia by Capricorn Link (Australia) Pty Ltd., P.O. Box 704, Windsor, NSW 2756 Australia

Kodak and EasyShare are trademarks and tradedress used by Lark Books under trademark license by Kodak.

Kodak
LICENSED PRODUCT

If you have questions or comments about this book, please contact:
Lark Books
67 Broadway
Asheville, NC 28801
(828) 253-0467

Manufactured in China

ISBN 13: 978-1-57990-806-5
ISBN 10: 1-57990-806-3

For information about custom editions, special sales, premium and corporate purchases, please contact Sterling Special Sales Department at 800-805-5489 or specialsales@sterlingpub.com.

Table of Contents

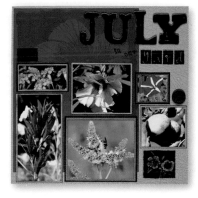

Creative Scrapbook Basics

Scrapbooking Your Favorite Photos

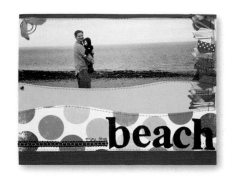

Photos. They capture and preserve life moments, from those of international importance and historical significance to more personal moments that are vitally important to us. They help us remember the slant of sunlight on a child's hair in mid-summer—a sight that made our heart rise in our chest. They record holidays with grandparents who are no longer with us, birthdays and other events that mark the passage of time. Scrapbookers recognize the importance of photos and, as such, preserve theirs in the most safe environments available.

A Brief History of Photography

The seeds of modern photography were planted in ancient times when camera obscuras were used to create images on walls in darkened rooms. As understanding of science and technology developed, modern photography was made possible.

- 1816: The camera obscura is combined with photosensitive paper
- 1826: The first permanent image is created
- 1834: The first permanent negative image is created
- 1837: Daguerreotype images are created on silver-plated copper
- 1854: Carte-de-visite photography is developed, creating a portrait boom
- 1861: Color photography is introduced to the public
- 1888: The first Kodak camera is created
- 1900: The Kodak Brownie box roll-film camera is introduced
- 1963: The first color instant film is developed by Polaroid
- 1983: Kodak introduces the disk camera
- 1985: Minolta markets the world's first autofocus SLR system
- 1992: Kodak introduces PhotoCD

Modern scrapbooking is more than just the safe archiving of photos. It is the creation of stunning pieces of artwork, built specifically to showcase beloved photos. Today's scrapbooking utilizes stunning papers and embellishments and a wide variety of techniques to create the artwork. Equally important to many scrapbookers is the journaling of facts and feelings on their scrapbook pages. With photos and journaling, scrapbook pages created today will allow future generations to know more about their heritage.

Blow

Festive patterned papers are mounted on pink cardstock as a foundation for two matted photos. A sticker letter title is mounted over colorful circles that mimic the round-and-round motion of the child's whirly toy. Colorful brads and a silk flower embellish the page.

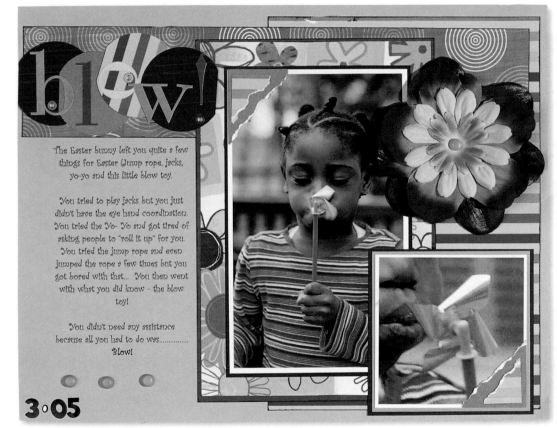

Yolanda Williams

Storing Photos and Negatives

Safely stored, photos and negatives can last for a very long time. Keep these facts in mind when storing your photos and negatives:

- Photos and negatives should be stored in photo-safe envelopes and sleeves.
- Photos and negatives should be stored in photo safe containers, binders or boxes.
- Photos and negatives should be stored in dark, dry environments.
- Store at temperatures between 65-70 degrees and with 30-50 percent humidity.

For many scrapbookers, the key to modern scrapbooking lies in the archival qualities of today's products. Papers and other supplies created for scrapbooking are usually photo-safe, which means they won't cause photos to yellow and become brittle. As scrapbooking has increased in popularity more and more supplies have become available and today, the selection is virtually endless.

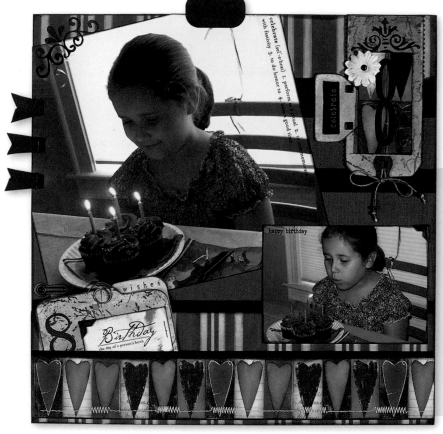

Patti Milazzo

Birthday

Patterned papers, tags, label tape, stamped images, swirl pins, fibers, brads and photos come together to make this birthday page something to celebrate. Journaling is hidden on the tag at the bottom of the page.

Where to Look for Supplies
* Hobby and craft stores
* Office supply stores
* On-line scrapbook stores
* Scrap clubs that deliver monthly "kits" including papers and accessories
* Scrap swaps where friends come together to share supplies
* Big box stores
* Photo stores
* Consumer craft conventions

What Products Are Archival?

* Page protectors (protective sleeves for your scrapbook pages) and memorabilia keepers that are PVC-free. PVC releases fumes that damage photos and paper.

* Permanent pigment inks. Inks that are not marked "permanent pigment" will fade and may bleed.

* Photo-safe and acid-free adhesives. Other adhesives may cause photos to buckle and warp and may cause discoloration.

* Photo mats, borders and other paper page elements made from buffered paper. The buffering of paper prevents the chemicals within it from yellowing and damaging photos.

* Acid- and lignin-free albums. These provide a safe environment for your photos and memorabilia and are likely to hold up over time. Do not scrapbook photos in "magnetic" albums (those popular scrapbooks that include a sheet of plastic that can be lifted to allow placement of photos and materials). Caught between the adhesive background and the PVC plastic, photos deteriorate quickly.

Embellishments

Anything goes when it comes to scrapbook embellishments, from "found" objects such as old jewelry and coins, to pre-made tags, stickers, die cuts, brads, charms, frames and much more.

Colorants

Paint, ink, colored pencils, rub-ons and pens add color to scrapbook pages. These photo-safe colorants are used to "age" heritage page elements, journal, add dimension and distinguish papers.

Paper

Scrapbooking papers come in every color, pattern and texture imaginable. They are sold by the single sheet or are available in packages. Paper patterns are designed to work with most popular scrapbooking themes and, like fashions, designs change with the seasons.

Albums

The style of scrapbook album embraced by scrapbookers is highly individual. Albums come in a variety of sizes and offer a number of binding options. Some are built like three-ring binders, while others secure scrapbook pages inside with a post or strap-hinge system. Scrapbook albums can be ornate or simple. No matter what the size or style, albums should be made of buffered and lignin-free papers. Use only PVC-free page protectors (transparent sleeves into which you slip your finished artwork. The sleeves have holes which are inserted into the album's rings etc.).

Additional Scrapbooking Supplies and Tools

- Adhesives: Available for every project, from applying tiny beads, to matting photos and memorabilia

- Cutting Tools: Decorative and straight-edge scissors, punches, shape-cutting machines

- Sewing Machine: For stitching together paper pieces and creating decorative backgrounds

- Page Protectors: PVC-free plastic envelopes that hold scrapbook pages and can be bound into albums

- Memorabilia Holders: Envelopes and other storage systems that can contain and often display memorabilia on scrapbook pages

- Rulers, Decorative Rulers, Templates: Rulers and decorative rulers make cutting straight-edges or patterns a breeze. Templates help in the creation of letters and patterns.

The simplest scrapbook page background involves the use of a single sheet of heavy paper (cardstock). Cardstock is available in a rainbow of colors and popular cardstocks often come textured as well. A single piece of cardstock, displaying mounted photos, a journaling block and embellishments can produce a clean layout. However, artists often seek ways to mix-and-match papers for complex effects. Two of the more popular techniques include color blocking and paper layering.

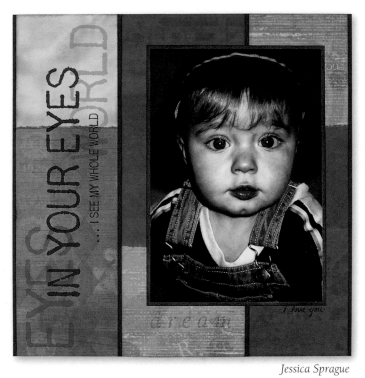

Jessica Sprague

In Your Eyes

When a photo is this good, it is often wisest to keep the layout as simple as possible. Mount blocks of patterned papers on brown cardstock. Mount the photo on brown cardstock. Print the title directly on your patterned paper and mount it along the vertical side of the artwork.

Color Blocking

Color blocking involves cutting blocks of paper and puzzle piecing and adhering them to a sturdy piece of cardstock. Photos and other page elements are mounted on the color blocked background. There are an endless number of templates available that make color blocking easy.

Easy Color Blocking

This simple scrapbooking technique is a quick and fun way to make beautiful scrapbook pages. There are also a wide number of design templates available to make color blocking effortless.

Step 1 Select your palette of color paper. Trim paper into color blocks to match your page design.

Step 2 Mount photos to cut cardstock with a "photo-safe" adhesive.

Step 3 Once you have created all the color blocks apply adhesive and assemble on cardstock. The page may now be finished with journaling and additional embellishments if desired.

Paper Layering

Layering paper involves either the cutting or tearing of complementary pieces of paper and the arrangement of them on a background. The layered papers are adhered to the background in a way that provides balance to the photos, journaling and embellishments that will be mounted on top.

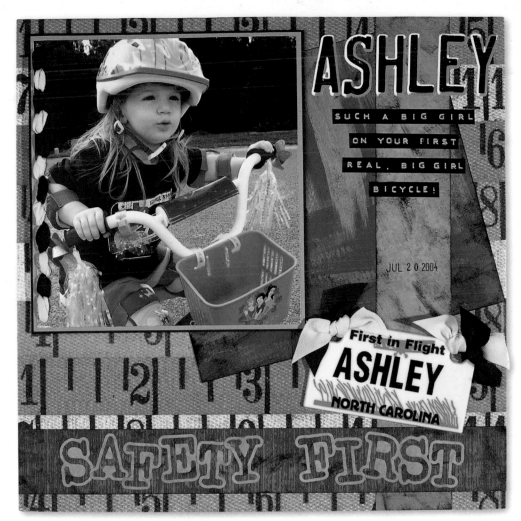

Carrie Zohn

Basic Scrapbooking Terms

MATTING Adhering a photo or other element to a larger piece of paper: The photo of the bike rider in the artwork, "Safety First," is "matted" first on pink paper and then double-matted on black cardstock.

MOUNTING Adhering a photo, mat or other element to the background page: The matted photo of the bike rider is "mounted" on the layered cardstock and patterned paper background.

CROPPING Cutting a photo to eliminate extraneous portions of the picture: The photo of the bike rider is "cropped" to eliminate trees, houses and other elements that may have appeared in the photo, drawing focus to the model.

EMBELLISHING Decorating a scrapbook page: The page, "Safety First," is embellished with a tag, ribbons, brads and fibers.

PAGE TITLE The "name" of a scrapbook page: The page title for the artwork above is "Safety First."

JOURNALING BLOCK A piece of paper or paper strips or labels on which names, dates and thoughts are written: The journaling for "Safety First" appears both on the tag and on label tape that runs up the right side of the page.

S tamping is an easy and versatile way for scrapbookers to create page backgrounds, page titles and embellishments. You can change the color of the design with just a quick change of ink pads. You can color in designs with markers and pencils, or make your stamped image gleam by embossing it. Stamps are economical and can be stored in plastic containers and stacked until needed again.

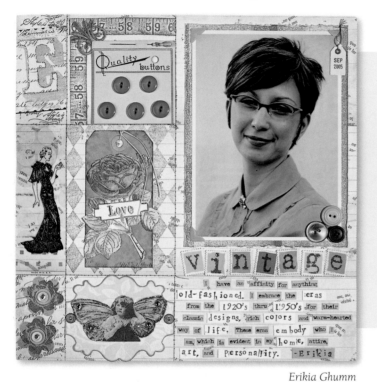

Erikia Ghumm

Stamping Inks and Stamps

- Dye Ink: Fast drying, produces a watercolor-like effect
- Pigment Ink: Archival and slow drying, best when heat set or used to emboss
- Watermark Ink: Archival, often transparent, used to create subtle designs
- Solvent Ink: Not-archival, perfect for stamping on nonporous surfaces
- Rubber Stamp: Hard surface stamp, used to create precise designs
- Foam Stamp: Porous stamp, used to make more distressed and more free-form patterns

Embossing

Embossing a stamped image creates a design that is raised and takes on a sheen. Embossing is easy to accomplish.

Step 1

Use pigment ink to stamp an image on your paper.

Step 2

Heavily sprinkle embossing powder over the wet stamped image. Tip your paper sideways to remove excess powder.

Step 3

Hold a heat gun several inches from your embossed image. In less than thirty seconds the image will take on a luster. Allow the image to cool.

Stamping Page Titles

A page title is the "headline" that prepares viewers for the information that will follow. Scrapbook titles are often seen at the top of pages, but may be found anywhere on the artwork. While straightforward titles announcing, for example, "Our Wedding," serve the purpose, many scrapbookers seek clever titles for their pages and may embellish the titles to enhance the artwork. There are many creative stamps that can be used in the creation of a title. Find one that adds to the mood of your artwork.

You Go Girl!

Fun and funky dotted stamp patterns are used to create the "You Go" portion of the title on this free wheeling page. The title crosses from the hot green cardstock to the circle of stitched patterned paper. The "girl" portion of the title is created by photo copying and printing the model's patterned sweater and cutting the text letters from the printed paper. Smaller support images are embellished with tags, staples and swirl pins. Stapled ribbons add color to the layout.

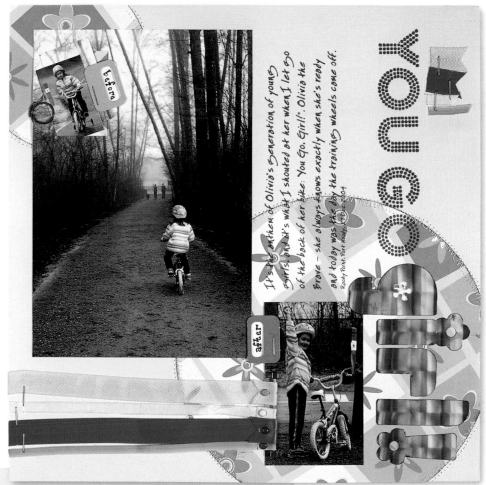

Mary-Catherine Kropinski

Where To Find Title Inspiration

- Advertising campaigns
- Product slogans
- Song titles and lyrics
- Movie quotes
- Nursery rhyme titles and verses
- Poems and limericks
- Famous quotes
- Family jokes
- Tourist brochures
- Book titles
- Advertising jingles
- Newspaper headlines
- Product packaging
- Restaurant names
- Street names
- Old sayings and proverbs
- Religious texts

Y ou don't need to be a seamstress to successfully bring the art of sewing to your scrapbook page. Practically unheard of several years ago, now more and more scrapbook artists are raiding their local sewing store for fabric, lace, thread, buttons, ribbons and fibers. They are buying needles and thread or getting their trusty old sewing machines tuned up to stitch pages for their albums

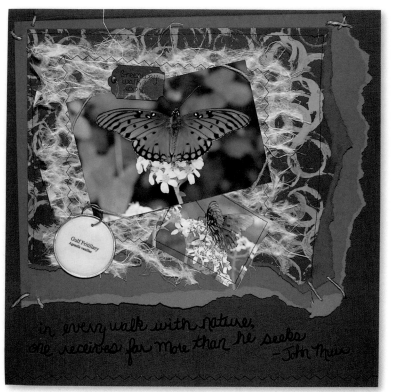

Greenway Walk

Mulberry paper froths around a spectacular photo of a butterfly on this nature page. The mulberry is sewn to a piece of patterned paper and again to a ripped piece of green cardstock. The corners of both the photo and green photo mat are hand stitched. A support photo is slipped under the focal print and stitched around its edges. A zigzag border accents the journaling at the bottom of the page.

Kate Childers

Enjoy the Beach

Stitching plays an important role in the success of this ocean side layout. Patterned papers and cardstock are straight stitched along their borders to replicate the sense of waves. The top of the photo is stitched to the pink background. Ribbons are folded in half and stapled to the right side of the layout. A fabric store ribbon , tiny silver heart brad and swirl clip finish the design.

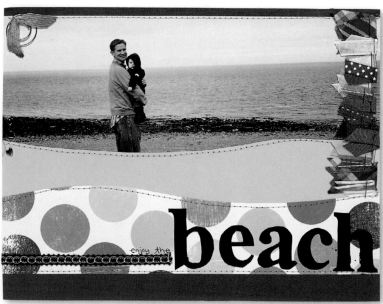

Rhonda Steed

Patterned papers and colored cardstocks can offer a scrapbooker many choices when it comes to selecting a color palette. But sometimes just the right color can't be found. Or perhaps you wish to create your own designs and colorize them to your taste.

Road Trip

The lush colors of nature vibrate on this artfully colored page. The background is sprayed with brown ink and the edges are painted blue. The printed title is outlined with green marker, as are the photo corners. Brown stamping inks are rubbed over paper elements to add a rustic feeling to the layout.

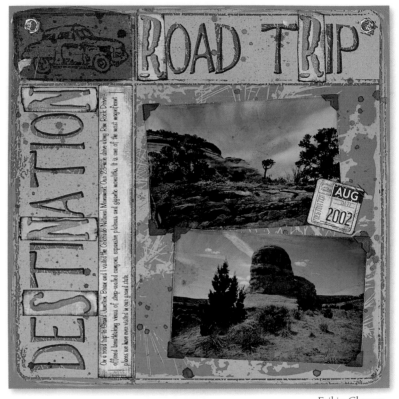

Erikia Ghumm

Colorants and Their Uses

Watercolor: Used to create gentle page backgrounds; can be used as a pastel wash, or more intensely to actually paint landscapes or design

Acrylic Paints: Perfect for painting the edges of photos in lieu of a photo mat, painting embellishments including brads, frames and bookplates. May also be used to create page titles through templates.

Stamping Ink: Made for stamping, it can be used to ink edges of torn papers, photos and for wet and dry embossing.

Pigment Pens and Markers: May be used for drawing patterns directly on papers, creating decorative borders or faux stitching

Colored Pencils: Useful for journaling and coloring in stamped designs

Stains: Stains "age" scrapbook papers and are often used on heritage pages.

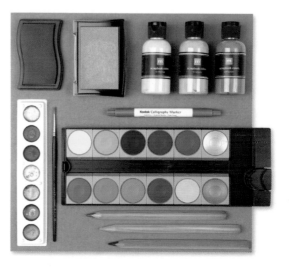

Dolling up a scrapbook page is just plain fun. And it is becoming more and more so as manufacturers design and market a wider range of embellishments. However, all embellishments for scrapbook pages are not necessarily designed for the craft. In fact, if you stretch your imagination, potential embellishments are everywhere.

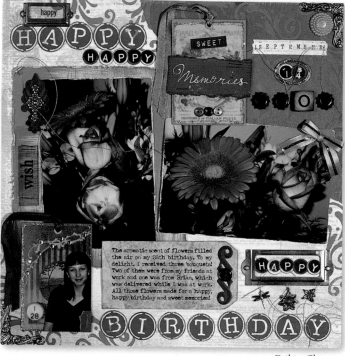

Erikia Ghumm

Happy Birthday

A box full of embellishments makes this birthday page as joyful as possible. Buttons, ribbons, stickers, bookplates, vintage jewelry, stamped wooden blocks, charms, jewels, decorative metal page corners, brads, game pieces and more add dimension to the layout. The edges of the floral photos are frayed, giving them a more casual feeling and the journaling block recalls the arrival of those special flowers.

Scrapbook and Hobby Store Finds

Metal bookplates, frames, tags, beads, pebbles, rub-ons, envelopes, brads, eyelets, snaps, colorants, silk flowers, miniatures, organics

Antique Store and Flea Market Finds

Old jewelry, heritage photos, eyeglass frames, old hardware, lace, buttons, vintage magazines and books, vintage coasters, maps, baby spoons, embroidered linen, journals, vintage postcards and stamps

Office Supply Finds

Paper clips, staples, labels, stickers, rubber bands, sticky notes, CD disks, hole punches, label tape, hole reinforcers, pens and markers

Fabric Store Finds

Lace, ribbon, rickrack, embroidery thread, patches, fabric, zippers, snaps, buckles, bobbins, buttons, hooks and eyes

Hardware Store Finds

Screws, nails, washers, paint chips, wire, mesh drywall tape, duct tape, screen, copper sheeting

Hunter

You don't have to hunt for a reason to love this terrific pet page with its inked papers and compelling photo. Brads, eyelets and snaps serve double duty, helping secure page elements and embellishing those elements. A green eyelet embellishes the journaling block, while tiny brass eyelets hold the decorative ribbon to the circular ring. Brads decorate the photo edges, secure a portion of the ribbon and appear again on the faux bookplate at the bottom of the page.

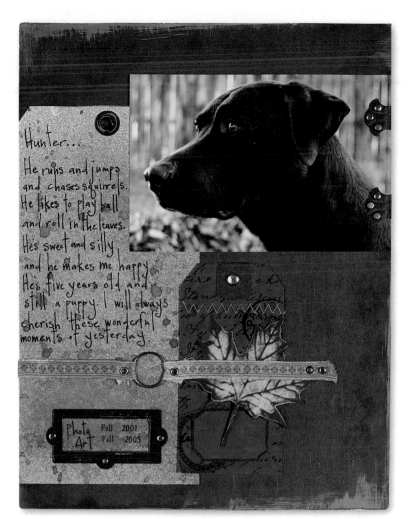

Erikia Ghumm

Setting Eyelets

Setting eyelets is a straightforward job if you have the correct tools.

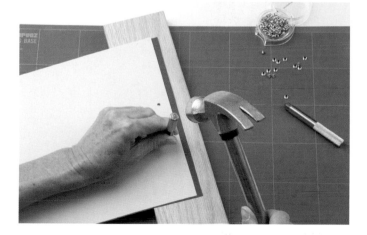

Step 1 Punch a small hole in your paper. Slip an eyelet through the hole from the under side of your paper. Turn the paper over, place your setting tool over the eyelet and strike the tool with a solid blow. (Work on a piece of scrap lumber.)

Brads, Eyelets and Snaps

Brads: Available in many colors, sizes and designs, brads are a decorative element set on top of two flexible prongs. To use, first punch a small hole in your paper. Insert the brad and fold back the prongs to prevent the brad from slipping free. Brads are used for decoration and also to secure photos, borders or journaling blocks to a scrapbook page. They are perfect when attaching mesh or handmade paper. Once set, you may wish to wind fibers around the brads.

Eyelets: Like brads, eyelets are available in a number of colors and sizes. They are circular with hollow centers. The top portion of the eyelet is positioned on top your scrapbook page. Directly beneath, you set the corresponding portion of the eyelet. When the two sections are joined, they create an opening through which fibers can be tied.

Snaps: Snaps are installed by snapping together a piece on top of your page to a linking piece beneath. Snaps are solid and do not create a hole in your paper. Some snaps are removable, but most, once set, are permanent.

First, there were silent movies. But people longed to hear the words behind the pictures. Those facts, those thoughts and emotions added dimension and brought the images to life. Journaling performs much the same task for scrapbook pages. Well-written journaling can help put the photos in perspective and enrich the viewing moment by filling in the gaps and allowing a viewer to truly experience the events unfolding through the eyes and hearts of those who were there.

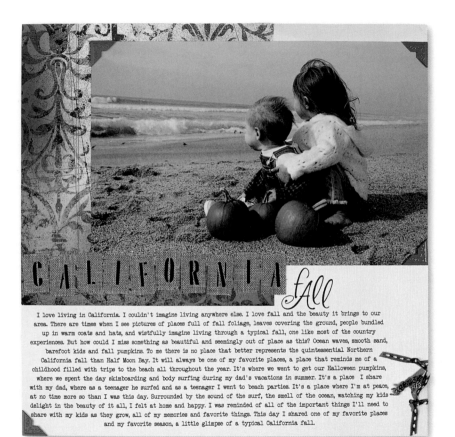

Heather Thompson

California Fall

A simple layout of photo, patterned papers and ribbons becomes a truly spectacular page because of the extensive journaling.

"I love living in California. I couldn't imagine living anywhere else. I love fall and the beauty it brings to our area. There are times when I see pictures of places full of fall foliage, leaves covering the ground, people bundled up in warm coats and hats, and wistfully imagine living through a typical fall, one like most of the country experiences. But how could I miss something as beautiful and seemingly out of place as this? Ocean waves, smooth sand, barefoot kids and fall pumpkins. To me there is no place that better represents the quintessential Northern California fall than Half Moon Bay..."

Heather Thompson

What To Include in Journaling

- Dates
- Names/relationships of those in the photos
- Occasion/Event
- Why the event was special
- The sounds, tastes, smells and sensations you associate with the event
- How the event made you feel and how you feel looking back on it
- What you learned from the event
- What you wish others who view your scrapbook page might take away

Sleep

A clean white background and strips of patterned paper support the compelling photo on this page. A quote sums up the artist's feelings about her photograph.

"He seems the incarnation of everything soft and silky and velvety, without a sharp edge in his composition, a dreamer whose philosophy is sleep and let sleep."

H.H. Munro

He seems the incarnation of everything soft and silky and velvety, without a sharp edge in his composition, a dreamer whose philosophy is sleep and let sleep.

H.H. Munro

SLEEP

Mary Rose and her snooze buddy, Kobe

2005

Laura O'Donnell

Stickers and Rub-ons

There are products waiting on the shelves of your local scrapbook or hobby store that can make journaling easier, on those occasions when you can't wrap your mind or pen around the words. Look for rub-on phrases that can be easily transferred to your pages. Stickers are also available with a wide range of sentiments. In addition, transparencies offer scrapbookers an easy way to convey their thoughts.

January February March April May June July august September OCTOBER November december SUMMER Winter SPRING Fall AUTUMN

When the Writing Muse Doesn't Speak

- Listen to music
- Turn off the television
- Read your favorite book of poems
- Go for a walk and clear your head of all thoughts and sounds. All new thoughts to filter in
- Pick up a book of philosophy or a book of quotes
- Pick up a pen and begin to "free write," jotting down every thought that comes into your head
- Call a friend and tell her why scrapbooking this/these photos are important
- Review your journal writing or diary for clues about your feelings

That face, that face, that beautiful face! Whether posed and pensive, or animated and in motion we meet the world face-on. Portraits capture the special qualities of individuals. Scrapbooking portraits can create artwork that is as unique as the face featured in the photos. Embellishments and journaling reinforce the idea that each of us is one-of-a-kind and precious in very different ways.

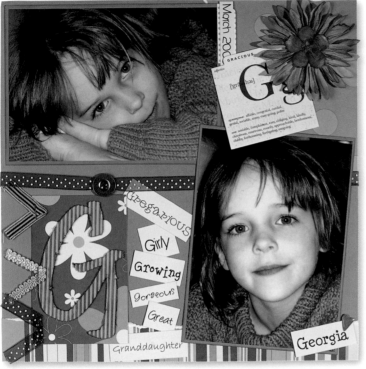

Katie Tate

G

The letter "G" stands for so many things including "gregarious," "girly," and "gorgeous"—all describing the child in these photos. The earthy green background paper is given a blush of girlish flavor with pink journaling blocks that tie in the pink within the patterned paper. The flower is inked, to give it a more natural look. The large "G" is cut from corrugated cardstock and it, along with the ribbons, adds texture and dimension to the page.

Morgan

Four fabulous black-and-white photos fill this page, making it quick and easy to create. A chipboard letter and rub-ons form the title. A column of adjectives supplies all the journaling necessary.

Make the Most of Your Photos

A collection of portrait photos can be used to create a compelling puzzle when pieced together. The secret to making this type of layout design work is to print and crop the individual pictures different sizes, which prevents the layout from appearing stagnant.

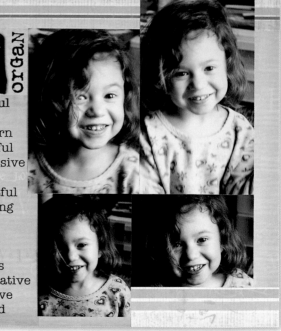

Kim Musgrove

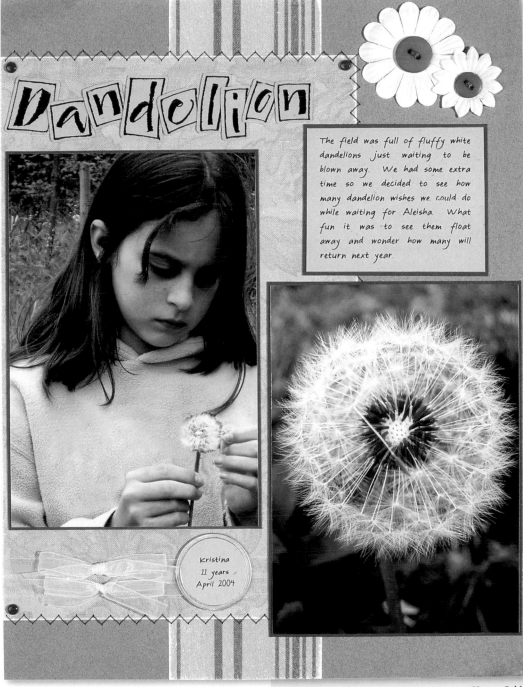

The field was full of fluffy white dandelions just waiting to be blown away. We had some extra time so we decided to see how many dandelion wishes we could do while waiting for Aleisha. What fun it was to see them float away and wonder how many will return next year.

Kristina
11 years
April 2004

Karen Cobb

Dandelion

Magically delicate and yet no push-over, dandelions have a lot in common with pre-teens. This page displays photos that capture the magic that takes place when these two miracles meet. A stitched paper block holds the matted photo of the girl. Satiny ribbon, a metal-rimmed tag, brads and flowers embellish the page. A poetic journaling block and stamped page title complete the picture.

Make the Most of Your Photos

Move in close...closer...closest with your camera to explore a flower. The webbing and froth of its seed can't be appreciated unless witnessed at a distance so close that your breath makes it dance. Extreme close-up photos of nature make its magical qualities real.

ABOUT FACE

Thomas, you have one of the most expressive faces I have ever seen. I love watching you no matter what you are doing. It just doesn't matter because you are always so precious, so sweet, and yes, so hilarious. I took these pictures of you during the months of July & August 2004. They speak so well to your different faces, moods and abilities. I am so thankful for you and for your sweet little face that I can look at and love both now & for years to come. I am really the lucky one!

Thomas Graham Cole

About Face

An intimate close-up portrait on the left side of this layout provides an island of visual calm, perfectly balancing the barrage of smaller photos filling the right page. Label tape points out the varying traits that make this child diverse, fun and well rounded.

Make the Most of Your Photos

To make cropping your photos for a multi-photo page easier, measure your page and pencil in grid lines. Create a block template the same size as the grid squares. Place the template over your photo and use a craft knife to carefully cut around the picture.

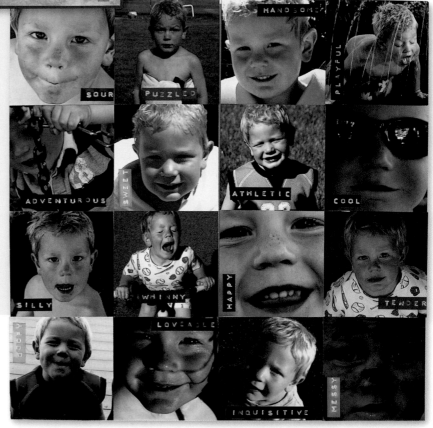

Samuel Cole

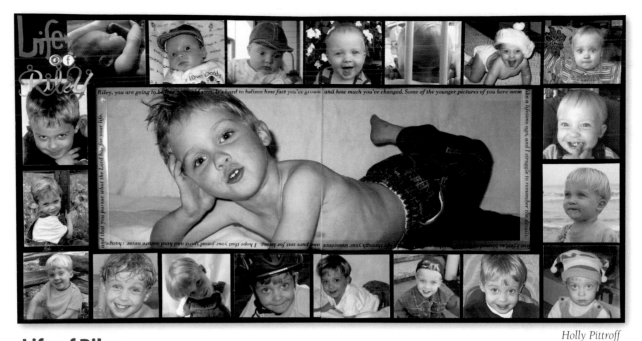

Life of Riley

Record the ever changing looks and personality of your child on a spread that features a series of photos from birth to the present. With a spread this joyful, minimal embellishment is required.

Holly Pittroff

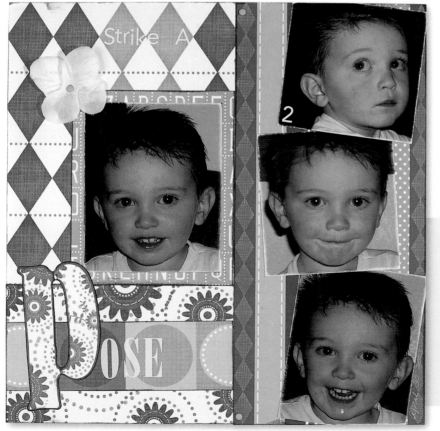

Strike a Pose

Scrapbook a handful of photos on a mix-it-up collection of patterned papers and you've got a winner of a page. Embellish with a die-cut monogram, brads and a silk flower as well as rub-on words.

Make the Most of Your Photos

A smiling portrait seems to be the goal of most photographers, but photos that show a variety of expressions paint a clearer picture of a personality. So don't wait for the smile, take photos of the expressions between grins.

Carolyn Lontin

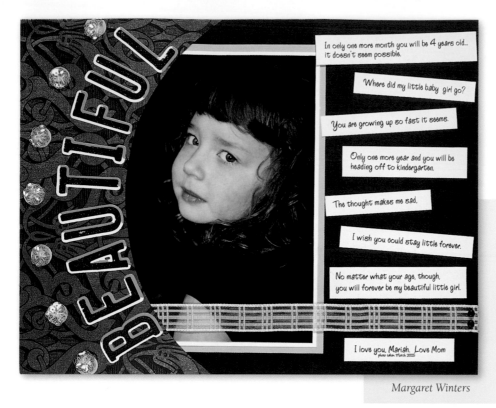

Margaret Winters

Beautiful

A boldly beautiful title follows the curve of patterned paper on this stunning page. Journaled captions are mounted on black cardstock. A web of ribbon creates a border across the bottom of the page and tiny black brads adorn it. Punched circles pick up the pink in the child's cheeks.

Make the Most of Your Photos

Place your subjects near a window to take advantage of natural sunlight. While flash photography is often required, there is nothing like natural light to bring out the true colors of a child's perfect skin.

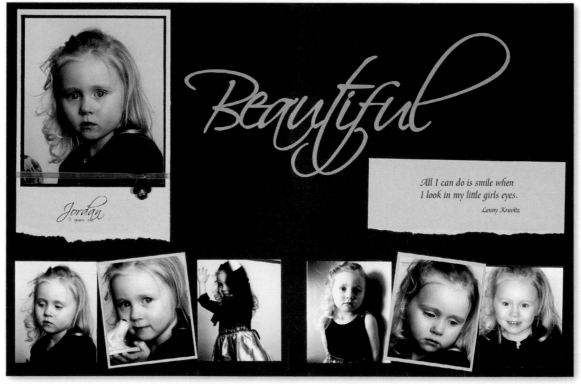

Kelli Dickinson

Beautiful

The grace and beauty of this little girl takes center stage on this stark but successful page. A laser-cut title and tiny charm balance the journaling block.

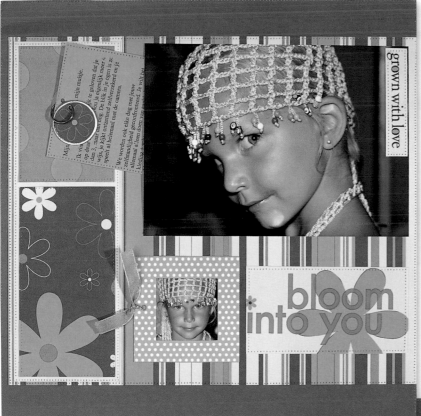

grown with love

bloom into you

Bloom Into You

Pieced and stitched patterned papers surround photos of a flowering beauty on this spread. Heartfelt journaling is detailed on a block that is slipped behind the focal photo. The floral theme is carried through with tags featuring floral designs. Spring green ribbon decorates a mini polka-dot frame that holds a small supporting photo.

"Its hard to believe you are just 3 here, going on 4 though, but still. You look so smart, secure and you know how to play with the camera already. Everyday we get confronted with your independence. You want to do it all by yourself, dressing up, putting on your shoes, fixing your sandwiches, playdates."

Peggy Severins

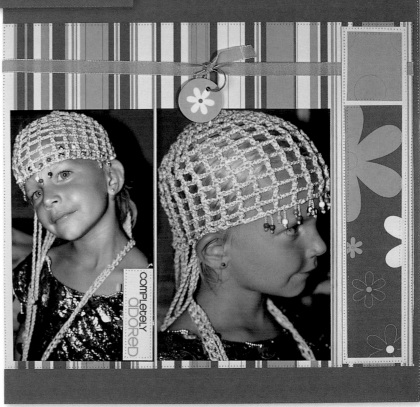

completely adored

Peggy Severins

23

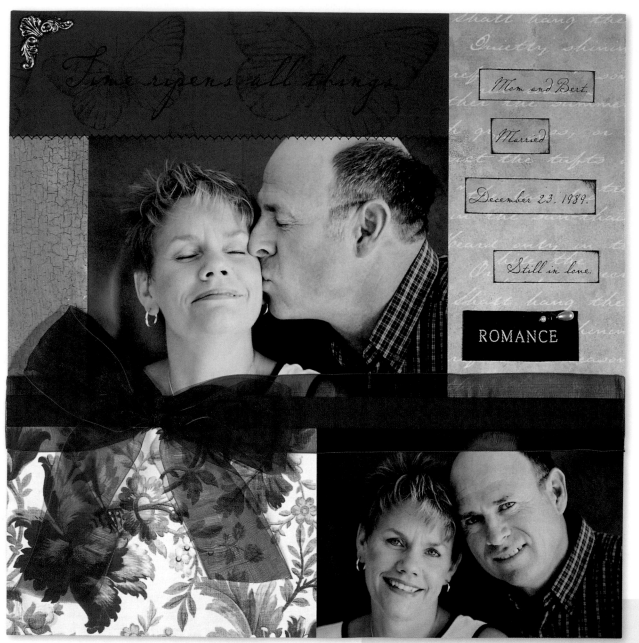

Mom and Bert

Married

December 23, 1989.

Still in love.

ROMANCE

Time ripens all things

Mary McCaskill

Time Ripens All Things

Seldom does a photo capture such pure and undiluted adoration as this one. The focal and support photos are scrapbooked on earthy patterned papers and rich florals. Journaled slips of paper line the right side of the page. An ornate corner embellishment adds gleam. Precise zig-zag stitching and a frothy bow tie up the layout.

Make the Most of Your Photos

If you cannot find just the right patterned paper to complement your photos, make it yourself. Stamp an image on a piece of paper. Scan the image and then manipulate it to vary its size. Print it on colored paper.

You Make Me Laugh

Life and love are just plain fun. Capture that emotion with lively animated photos and a fiery palette. Layer lush patterned papers beneath photos. Use rub-on words to create journaling. Alphabet stamps and rub-ons help make up the title. A stamp, bottle cap and fastener add to the page's charm.

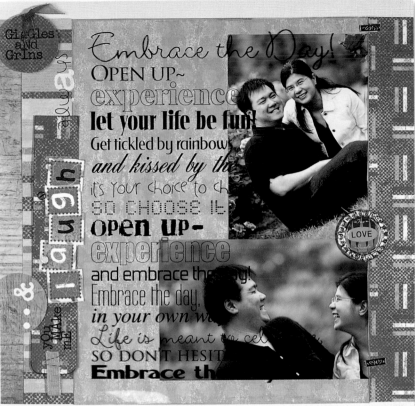

Liana Suwando

Tucker

Tucker is all tuckered out, but this page keeps going and going and going when it comes to appeal. The oversized photo is matted on vibrant red cardstock and mounted on patterned paper. Black cardstock forms the background. Letter stickers are used to create the title. A tiny paw print is stamped on the metal-rimmed vellum tag. Gingham ribbon provides an appealing touch.

"When Tucker was just a puppy he came to stay with us for 4 days while Nana & Papa were on vacation. Charlie was still a kitten and loved to tease Tucker. We spent a lot of time separating them. We love him...but he wore us out!"

Dawne Carlisle

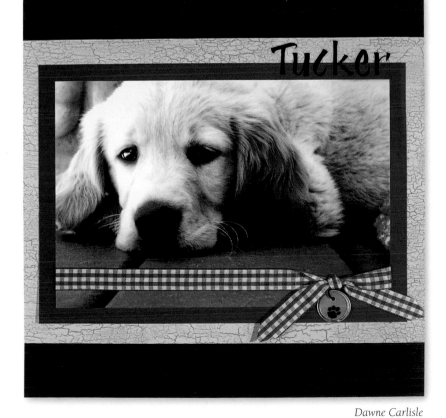

Dawne Carlisle

25

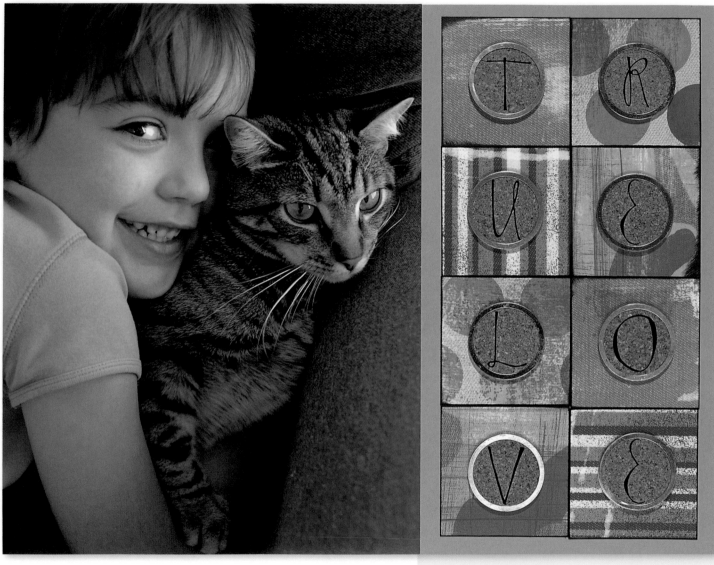

Laura O'Donnell

True Love

You know you've got a terrific photo if it can hold down two-thirds of a scrapbook page on its own, like this photo does! The other portion of the page is created with blocks of patterned paper. Rub-on letters are placed on top of cork tags and mounted on the blocks.

Make the Most of Your Photos

A belly-down photo of a child and her pet does not have to be mounted belly-down on a page! Consider turning the photo for a very different look and feel.

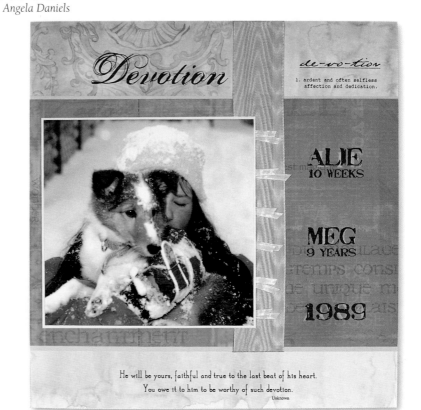

Hip Chick

Patterned papers against earth tone cardstock create an interesting and unusual palette for this funny photo. A stamped title and journaling block join a swath of teal paper and brads on the layout.

You have a beautiful wide smile like all happy toddlers but I mostly seem to capture your pensive side in pictures. I guess this is when you are most still and less likely to notice what I'm doing. Still, I am shocked at what a hip little chick you can manage to look like at the tender age of 1.

Reno Hot Air Balloon Races
September 2004

Angela Daniels

Make the Most of Your Photos

Stop yourself from telling your photo subject to say, "cheese." Those fake smiles are never as compelling as clicking a candid shot. Candid pictures of a child deep in thought capture the true personality of a subject.

Devotion

An assortment of fonts keeps this simple page from becoming mundane. The beautiful balance of journaling and title partially surround the stunning photo. Patterned papers and ribbon provide gentle color.

Devotion

de-vo-tion

1. ardent and often selfless affection and dedication.

ALIE
10 WEEKS

MEG
9 YEARS

1989

He will be yours, faithful and true to the last beat of his heart.
You owe it to him to be worthy of such devotion.
Unknown

Linda Garrity

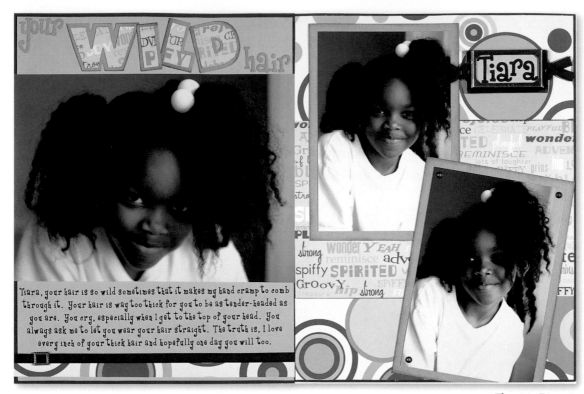

Thomisia Francois

Your Wild Hair

A page about wild hair just begs to be scrapbooked on a wild and crazy background of patterned papers. The "WILD" title is cut from the same patterned paper and matted on teal cardstock. Teal photo mats frame the supporting images. Eyelets, a bookplate, ribbon and a tiny ribbon charm embellish the layout.

Cheese

Smile for the camera kids! Smile! Smile! Oh well...that's how it goes some times. Scrapbook those "oh well" photos on playful backgrounds of patterned papers that provide a feeling of upbeat humor. Photo turns and a cheesy title, complete the quick-and-easy page.

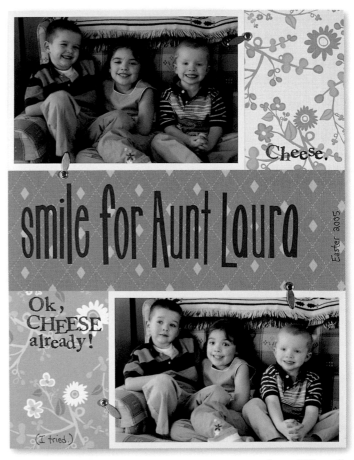

Laura O'Donnell

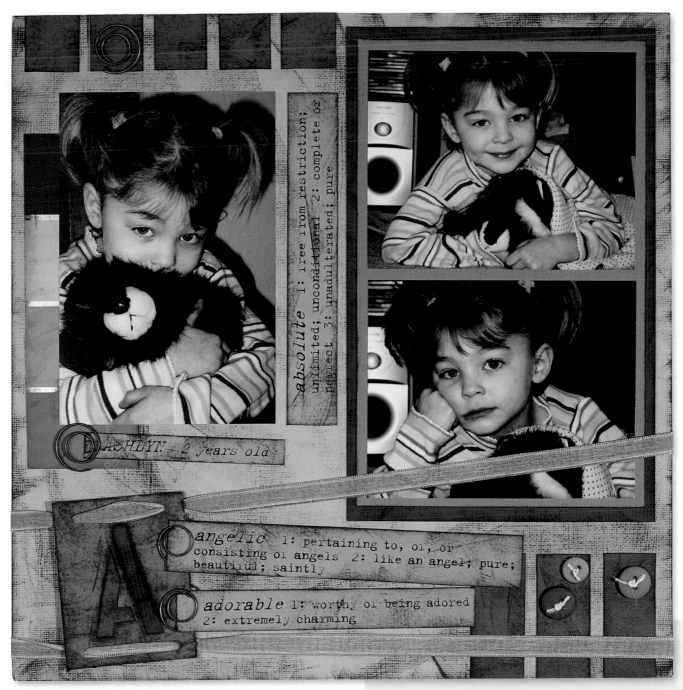

absolute 1: free from restriction; unlimited; unconditional 2: complete or perfect 3: unadulterated; pure

ASHLYN 2 years old

angelic 1: pertaining to, of, or consisting of angels 2: like an angel; pure; beautiful; saintly

adorable 1: worthy of being adored 2: extremely charming

Raechelle Bellus

A for Ashlyn

Inked cardstock supports images of this little doll. Blocks of cardstock are mounted on a cardstock base, while pink journaling captions are adhered in what appears to be random placement. A large stencil letter "A" is the inspiration for the journaling. Buttons, spiral clips and ribbon embellish the layout.

Make the Most of Your Photos

When you just can't decide on a color palette for your scrapbook page, visit your local hardware store. You'll find hundreds of paint chips that provide infallible color combinations.

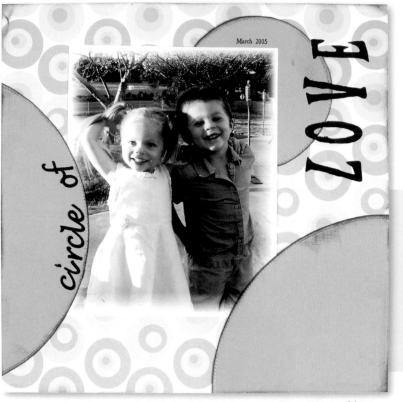

Tracy Weinzapfel Burgos

Circle of Love

Large circles of inked cardstock are delicately sewn to a background of circle patterned paper. The page design beautifully supports the title theme. Lettering templates are used to create the title while the date is stamped. The photo is engaging enough to hold its own against the active background.

Make the Most of Your Photos

Sanding the edges of this black-and-white photo gives it an aged look that works well with the "retro" pattern of the background paper. Remember to make a duplicate photo before attempting this technique.

Babies Smile

That face, that beautiful face! This scrapbook layout does everything possible to draw attention to those chubby cheeks. A torn purple page border holds a slide mount, under which five tiny photos are displayed. The focal picture is double matted, as is the journaling block, before being mounted on pastel checkered paper.

Denise DeYoung

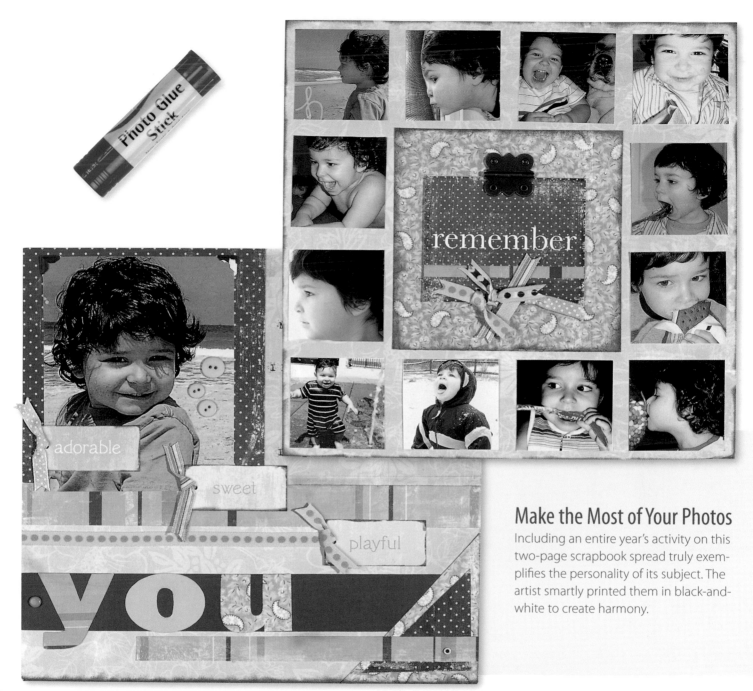

Netalia LaConti-Riggle

Make the Most of Your Photos

Including an entire year's activity on this two-page scrapbook spread truly exemplifies the personality of its subject. The artist smartly printed them in black-and-white to create harmony.

You

The many expressions of a child speaks to his multi-faceted personality. Scrapbook a wide collection of photos on a page to display personality plus. Mount journaling under a hinged die cut and add ribbons as pulls. Balance the spread with a left hand page that features a large focal photo. Journal on a decorative transparency. Add journaling tags, ribbon, buttons, brads and photo corners.

"The nurse sent me a letter to let me know you failed the vision screening and may need glasses...I was so worried you would be teased or called names when you wore your glasses at school...I was pleasantly surprised to find out that glasses are cool."

Jill Fickling-Conyers

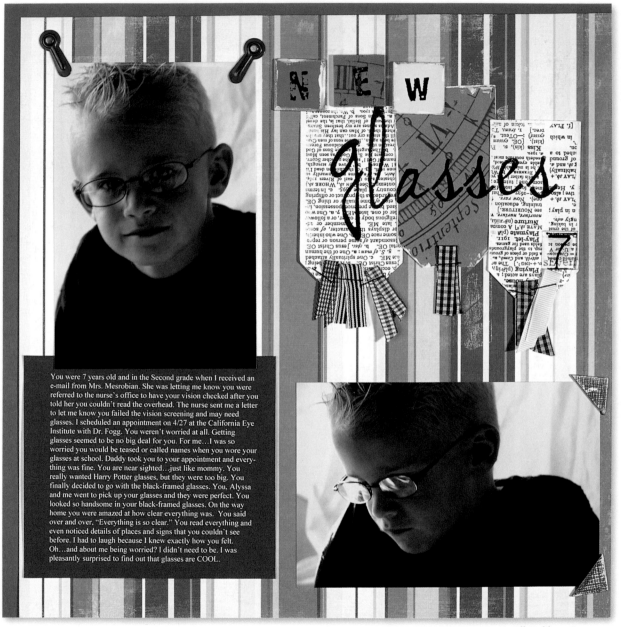

Jill Fickling-Conyers

New Glasses

With a new pair of glasses, you can see the world more clearly—you may even be able to read the script die-cut tags that are mounted upside down on this page! Scrapbook photos of those new lenses on masculine striped patterned papers. Chipboard title letters are handmade with paint, rub-ons and glaze. Sticker letters, photo corners and photo turns find their own place on this emotional page. The story is detailed in the extensive journaling block.

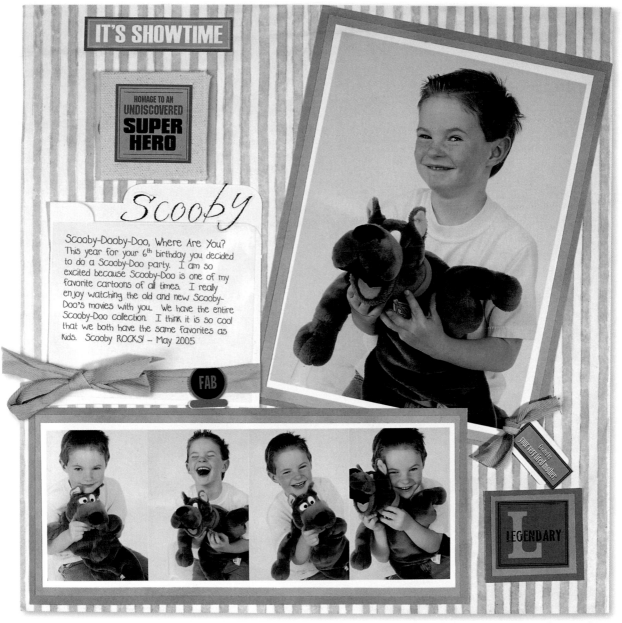

Martha Crowther

It's Show Time

This well-known character has proven his popularity to children over the decades. Scrapbook photos of Scooby moments on double photo mats and mount them on striped patterned paper. Add a few stickers and journal on a miniature library envelope. Fibers are all that are needed to complete the layout.

"This year for your 6th birthday you decided to do a Scooby Doo party. I am so excited because Scooby Doo is one of my favorite cartoons of all times...I think it is so cool that we both have the same favorites as kids."

Martha Crowther

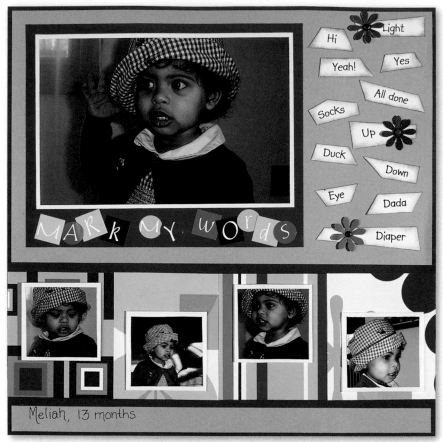

Words on tags: Hi, Light, Yeah!, Yes, All done, Socks, Up, Duck, Down, Eye, Dada, Diaper

MARK MY WORDS

Meliah, 13 months

Lisa Falduto

Mark My Words

It's amazing how many words a one-year-old can master. This page celebrates this little doll's acquisition of language. Words are written on arbitrarily cut and inked tags. Letter stickers on paper blocks create the bouncy title on the bottom portion of the focal photo's mat. Support photos are mounted on patterned paper at the bottom of the page. Punched paper flowers with mini brads accent the journaling.

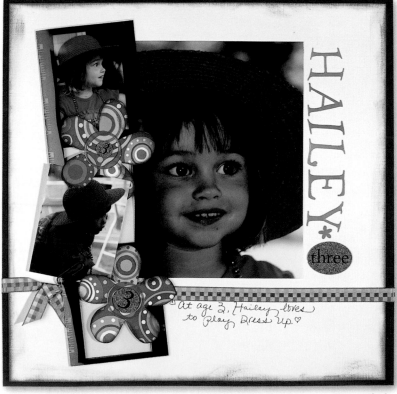

HAILEY *three

At age 3, Hailey loves to play Dress Up. ♥

Dress Up

Every little girl loves to dress up and this cherub is no exception. The focal photo is mounted directly on a cardstock background. Support images are mounted on a large negative transparency. Handcut paper flowers embellish the page, as does the ribbon and paperclip.

Renae Clark

The three dimensional embellishment is created with a circular tile. The black center of the tile is punched and adhered to the middle of the tile. The flower shape is stamped and mounted directly on top.

She

Patterned papers layered over a stark black background create contrast for this portrait page that pays tribute to a loved sister. Chipboard letters boldly shout the title, while a creative journaling block lists the attributes of the model.

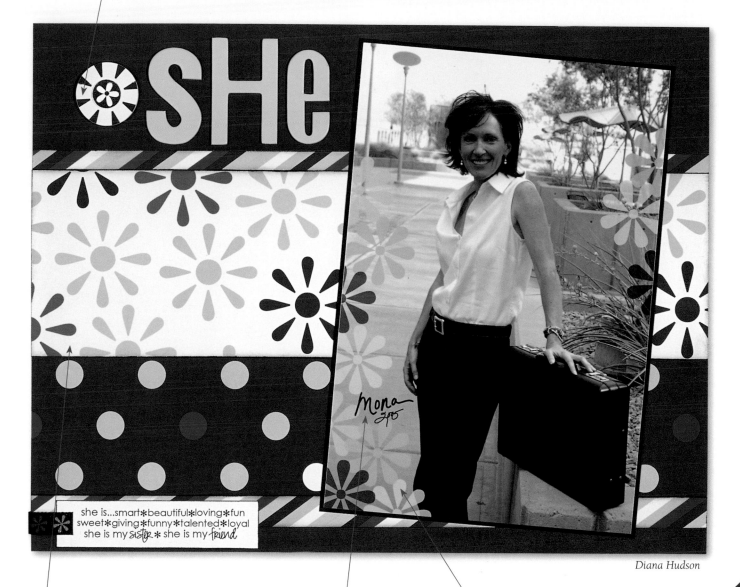

she is...smart✽beautiful✽loving✽fun sweet✽giving✽funny✽talented✽loyal she is my sister ✽ she is my friend

Diana Hudson

Ink the edges of strips of patterned paper and adhere to cardstock.

The journaling that appears on the photo is computer-printed directly on to the picture.

A computer software program is used to print the flower shapes directly on the digital photo.

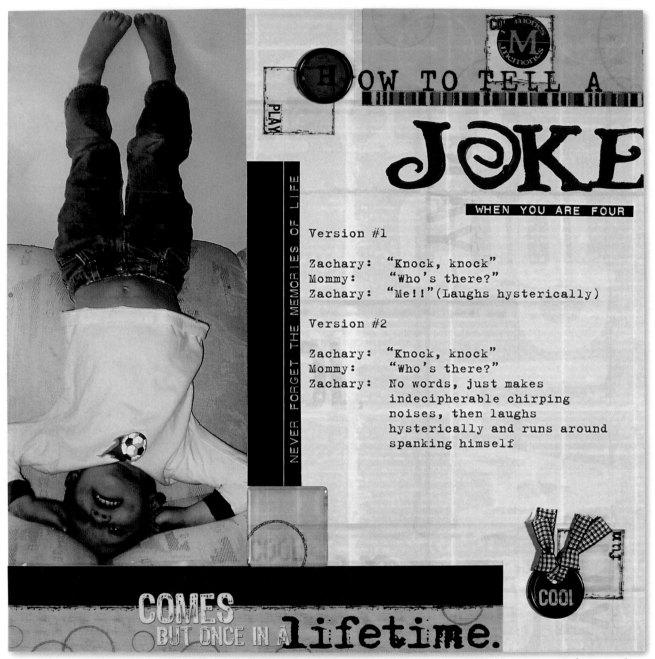

HOW TO TELL A

JOKE

WHEN YOU ARE FOUR

NEVER FORGET THE MEMORIES OF LIFE

Version #1

Zachary: "Knock, knock"
Mommy: "Who's there?"
Zachary: "Me!!"(Laughs hysterically)

Version #2

Zachary: "Knock, knock"
Mommy: "Who's there?"
Zachary: No words, just makes
 indecipherable chirping
 noises, then laughs
 hysterically and runs around
 spanking himself

COMES BUT ONCE IN A lifetime.

Stefanie Hamilton

How to Tell a Joke

Stand on your head. Grin like a Halloween pumpkin and let 4-year-old silliness fly. That's how you tell a joke! Keep the focus on the journaling for a super special page that serves up a true taste of a child's personality. Use patterned paper, epoxy stickers, patterned transparencies, conchos and ribbon to complete a wonderfully goofy page.

One Photo Two Ways

A monochromatic palette uses tints and shades of a single color. The result is a piece of artwork that speaks strongly to the mood conveyed by the chosen color. Photos scrapbooked on earth tone monochromatic palettes seem relaxed and laid back. The same photo scrapbooked on a page wild with diverse color is energized. Hot pinks, oranges, yellows and lime greens speed up your heart rate and appear to pop off of a darker or cooler background.

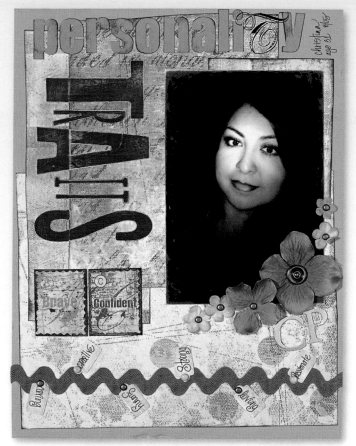

Christina Padilla

Personality Traits

Shades of cool green set the mood for this monochromatic page. Layered papers form the background for the partially matted photo. Paper letters and stamps are used to create the title. A small bouquet of flowers, brads, rickrack and stickers add to the design.

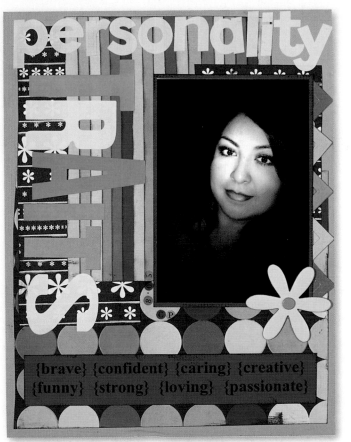

Christina Padilla

Personality Traits

Hot, hot, hot, the colors on this layout are almost florescent. The colored papers are layered and inked to form the spectacular background. A dark patterned paper provides a foundation for the vibrant shades. The paper title letters are as bold as the papers used. A journaling strip and large flower complete the page.

37

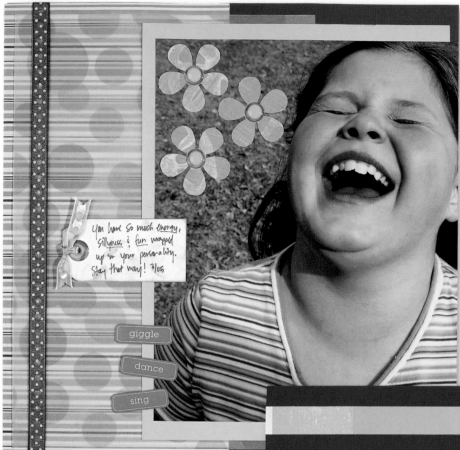

Kodi Giggle

Laughter can turn a dark day sunny, and this girl is responsible for lighting up the sky. Scrapbook upbeat photos on upbeat pink papers. Combine patterns and add spring flowers for embellishment. A colorful title, a tag and ribbons complete the page.

giggle

dance

sing

Make the Most of Your Photos

Integrate your page design with your photos by adhering punched paper flowers or other embellishments directly on your picture. Place similar embellishments on other portions of the spread for visual continuity.

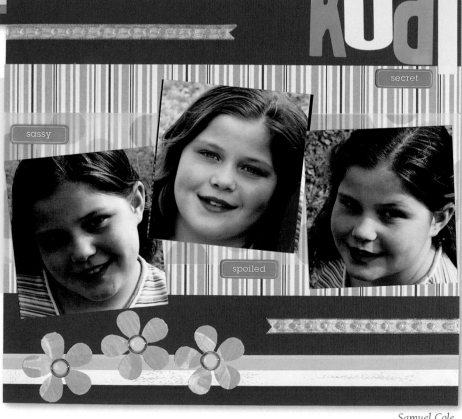

Kodi

secret

sassy

spoiled

Samuel Cole

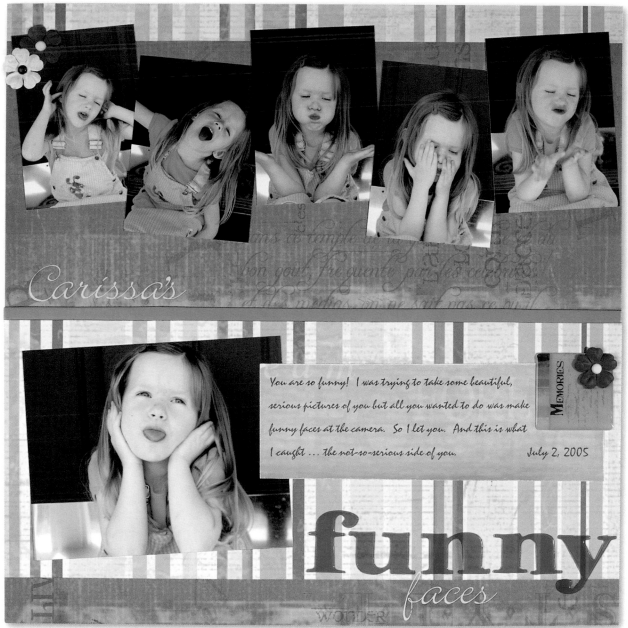

Carissa's

You are so funny! I was trying to take some beautiful, serious pictures of you but all you wanted to do was make funny faces at the camera. So I let you. And this is what I caught ... the not-so-serious side of you.

July 2, 2005

MEMORIES

funny
faces

Annette Pixley

Funny Faces

When a child is in a silly mood you may as well take advantage of it. Photograph her at her wildest and goofiest and mount the photos on a chipboard strip with transparent letters directly on patterned paper. Add a few sassy flower embellishments, a journaling block and rub-on letters and sit back and smile.

Enjoy
THE JOURNEY

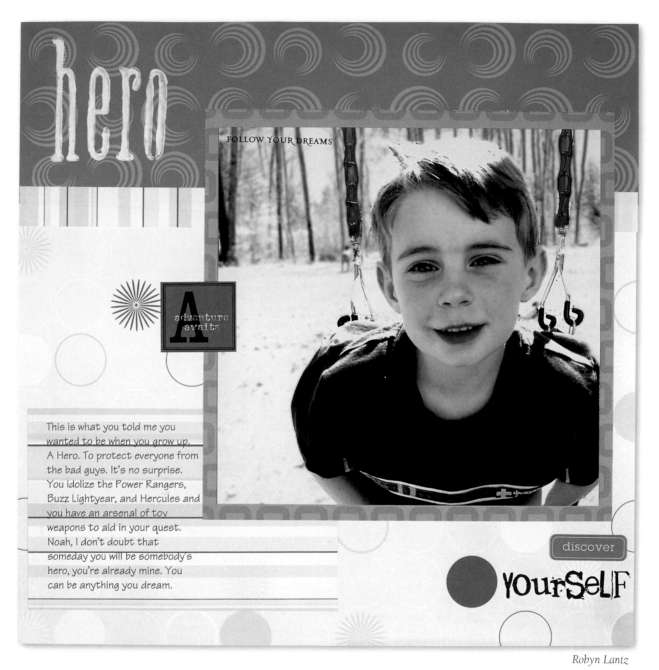

Robyn Lantz

Hero

Heroes are anything but ordinary and this page, with tangy orange patterned paper and captivating photo, reinforces this concept. A foam stamped title, rub-on words, and word stickers are underplayed, keeping the focus on the true hero of this layout.

"You idolize the Power Rangers, Buzz Light-year, and Hercules...Noah, I don't doubt that someday you will be somebody's hero, you're already mine."

Robyn Lantz

Birthday Girl

Letter tiles, a stencil and stickers are pulled together on this page, supplying both the journaling and embellishment. Two compelling photos reside between the journaling on neatly stitched patterned papers. Ribbons add a feminine touch.

Make the Most of Your Photos

Upside down or rightside up, little girls are lovely. Try to capture your favorite little model from above as well as the traditional face-forward view when taking photos.

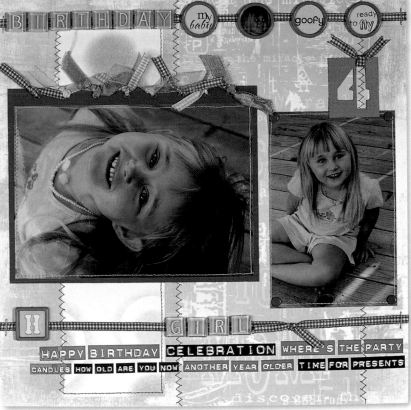

Johanna Peterson

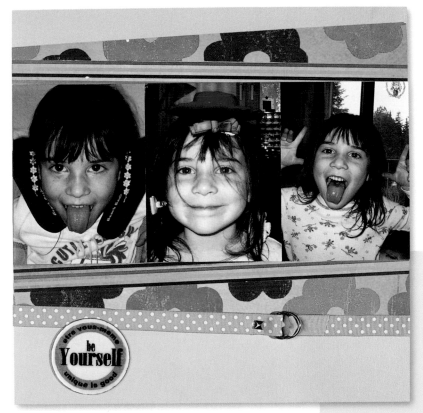

Be Yourself

It's called, "pulling a face" and this wild and wonderful girl has got it down to a fine art. Boldly colored floral and striped patterned papers are mounted at angles across lime green cardstock on either side of the three photos. A polka-dot buckled and studded ribbon and a "be yourself" chipboard coaster are added at the bottom of the layout.

Make the Most of Your Photos

If you're looking to bring out the sillies in your favorite little model, why not supply her with a basket full of goofy props and tell her to go crazy! Encourage the antics and be prepared to snap away!

Laura Alpuché

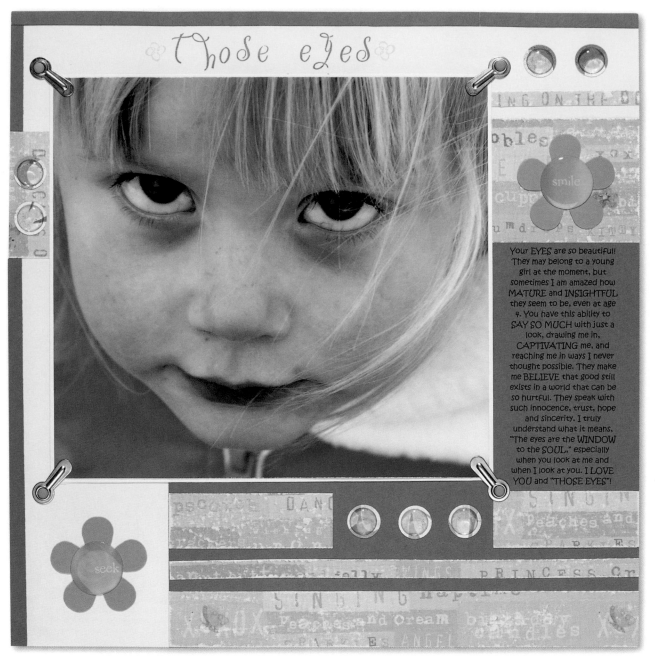

Your EYES are so beautiful! They may belong to a young girl at the moment, but sometimes I am amazed how MATURE and INSIGHTFUL they seem to be, even at age 4. You have this ability to SAY SO MUCH with just a look, drawing me in, CAPTIVATING me, and reaching me in ways I never thought possible. They make me BELIEVE that good still exists in a world that can be so hurtful. They speak with such innocence, trust, hope and sincerity. I truly understand what it means, "The eyes are the WINDOW to the SOUL," especially when you look at me and when I look at you. I LOVE YOU and "THOSE EYES"!

Samuel Cole

"You have the ability to say so much with just a look, drawing me in, captivating me and reaching me in ways I never thought possible."

Samuel Cole

Those Eyes

You could get lost in those baby blues and that's exactly what this layout asks the viewer to do. The closely cropped, over-sized photo draws you in, while yellow and pink cardstock and patterned papers support the image. Journaling, paper flowers, acrylic word pebbles and photo turns add to the magic of the page.

Girl

A vulnerably sweet photo of a young girl is triple matted and mounted on delicate pink cardstock. Patterned paper creates a page border. Journaling captions are stapled below a ribbon-tied tab down the border of the page. Brads add dimension to the layout.

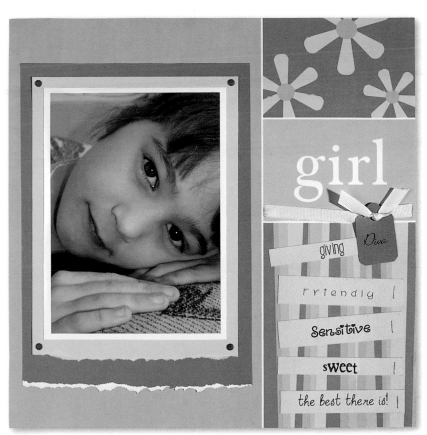

Rhena Failing

Sofie Girl

Ahhhhhhhhh. There's nothing quite as cute as a puppy. Scrapbook puppy photos on textured green and brown cardstocks and baby-pink word patterned paper. Use a foam stamp to create the title. A punched heart shape takes the place of the "i" in the raffle letter sticker alphabet word. Rickrack and ribbon embellish the page.

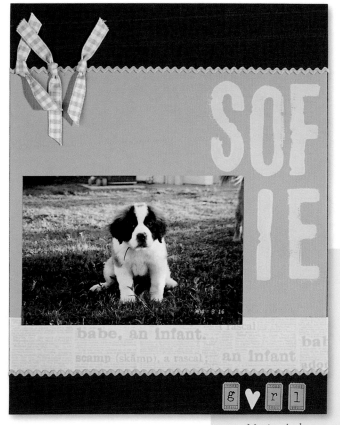

Monica Anderson

Make the Most of Your Photos

A GIANT title created with foam stamps creates perspective, making the puppy appear even more tiny. Consider varying the size of your page title for similar results.

"Everything about the five-year-old you amazes me.... I wish I could capture our moments together forever. Maybe that's why I'm so camera happy..."

Shay Brackney

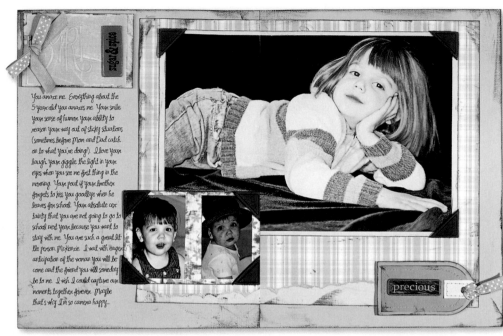

Shay Brackney

Precious Girl

A focal photo of a spunky 5-year-old is matted and then mounted on distressed yellow patterned paper and inked cardstock. Support photos show just how far this little girl has come in so few years. The title is created with a word tag and rub-ons. Ribbon, a safety pin and photo corners are understated, allowing the focus to remain on the photos.

July

It is "squintably" hot in July but that doesn't stop the fun. These starkly beautiful photos are scrapbooked on basket weave textured paper and black and yellow cardstocks. A ribbon holds a chair button and white brads secure journaling blocks to the page.

Make the Most of Your Photos

A monochromatic black-and-white palette can be highly dramatic, but it is the blaze of yellow that makes this page work. Consider adding a bold slash of color to your black-and-white layouts to supply a shot of energy and excitement.

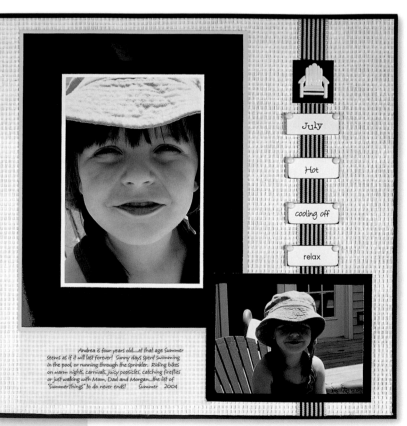

Dianne McInrue

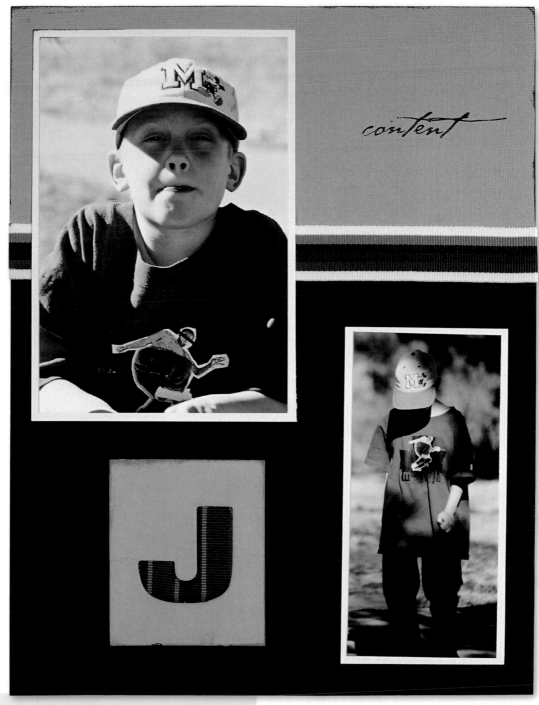

content

Shay Brackney

Make the Most of Your Photos

The artist uses the dramatic contrast of light and dark in these photos to add a level of interest to this simple and elegant page. The dappled light of a shade tree in summer evokes the quintessential feelings of summer.

Content

When photos are this strong, words seem to be extraneous to a layout. Black and blue inked cardstocks, a stencil letter "j," ribbon and a rub-on title word add to the success of the page.

Life doesn't stand still. It is a constant unfolding as event follows event. The question of what lies just around the corner provides excitement and we find ourselves moving forward to meet our next adventure. Capturing motion in photos can be tricky, but those hard-to-take photos make dynamic scrapbook pages. Scrapbook sequences of events, or stop time with a single sensational action shot.

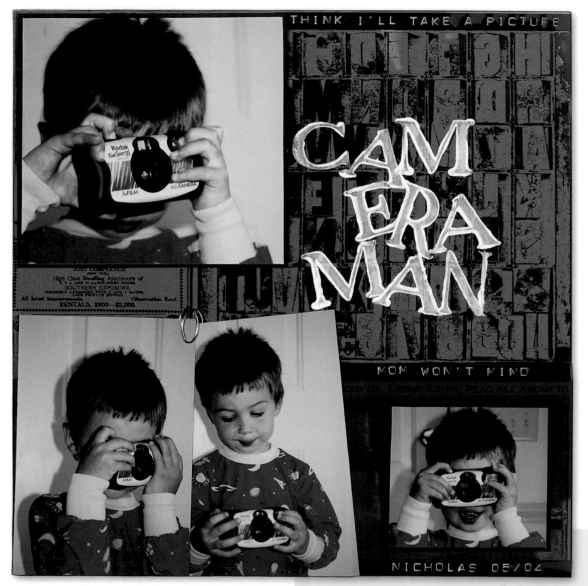

Maria Gallardo-Williams

Cameraman

Artists learn early to refine their medium and this little guy is no exception. He may not even have been aware that, while snapping away, he was being photographed. The sequence of photos are mounted on a stamped transparency.

Make the Most of Your Photos

Allow your children the chance to take their own pictures with a single-use or digital camera and then help them create their first scrapbook pages!

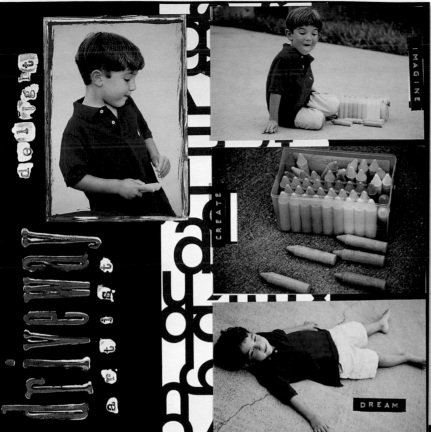

Driveway Artist

A black-and-white palette of background papers makes this young artist's vibrant shirt and his tools of the trade pop visually. Label tape captions lead the viewer through the process every artist pursues—as a vision takes form and moves from concept through execution. Stamped title words complete the spread.

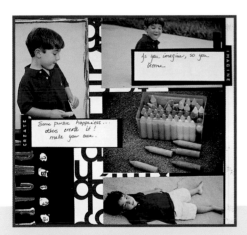

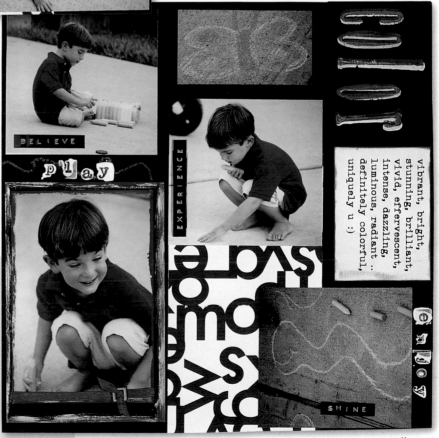

Make the Most of Your Photos

Look for clever ways to tuck away additional journaling captions. Consider sliding them behind label-tape captions so they can be withdrawn to be read. Slip them back into their slots when not needed.

Kris Gillespie

47

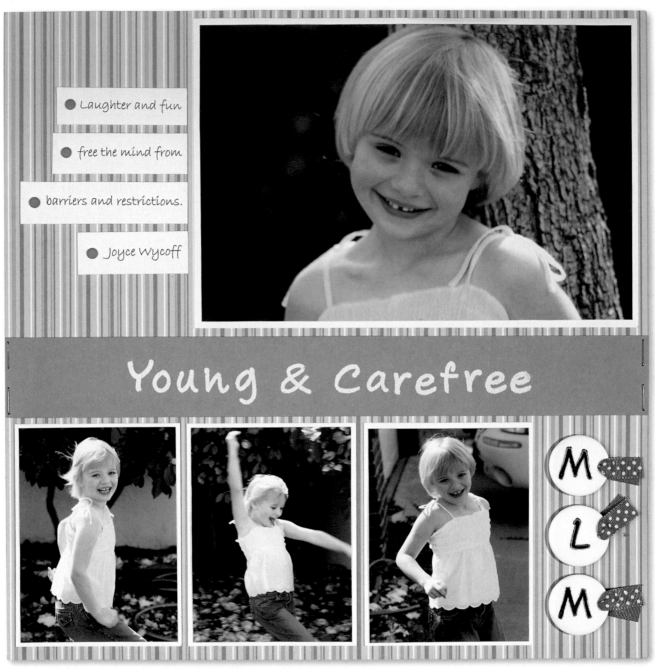

- Laughter and fun
- free the mind from
- barriers and restrictions.
- Joyce Wycoff

Young & Carefree

M
L
M

Sara Bryans

Young and Carefree

Who can forget those fantastic childhood days when the world was there for the plucking and we left our cares behind at the school room door? This page captures the kick-up-your heels fun of being a girl. Playful striped paper and blue cardstock create the background for these photos. Journaled strips are decorated with blue brads. A clean white title treatment is supported by round zipper pulls and flirty ribbon.

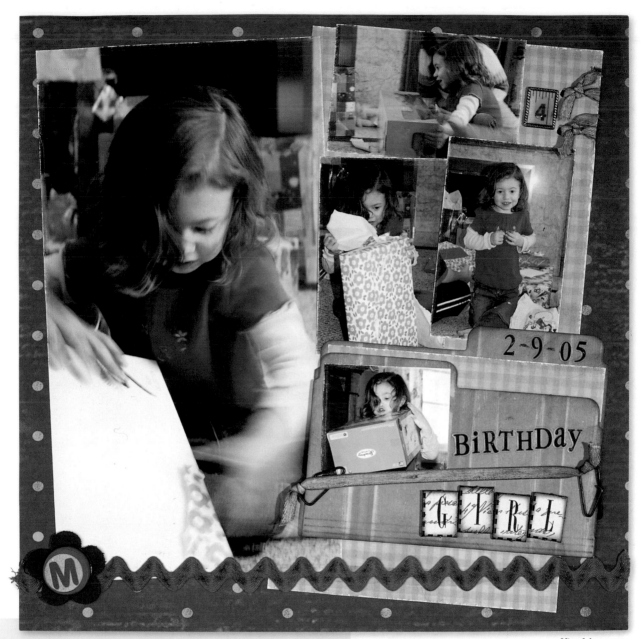

Kim Musgrove

Make the Most of Your Photos

Capture the excitement of a very, very busy moment by mounting photos in a haphazard manner that says, "I simply don't have time to worry about lining up these pictures! I have much more important things to think do!" (such as opening an astounding number of gifts!)

Birthday Girl

In the excitement of the moment it often seems impossible to get that darn wrapping paper off the birthday gifts fast enough! The occasion is displayed on a page filled with frenetic energy. A series of photos with distressed edges are mounted in what appears to be a haphazard fashion on layers of patterned papers. A miniature file folder serves as a block for a title formed with stickers and chipboard letters. It is decorated with an additional photo, fiber and clips.

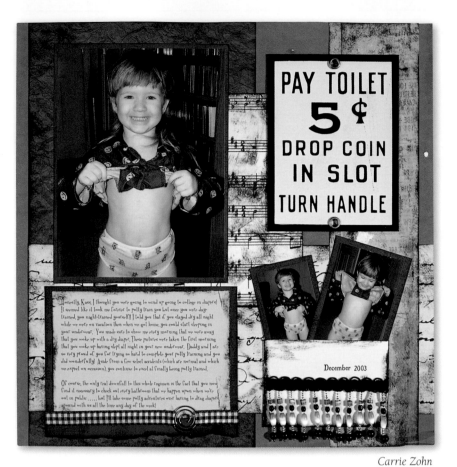

No More Diapers for Kassie

A little guy's pride in completing the move from diapers to big boy underwear is the theme of this successful page. Five different patterned papers and cardstock, all in tones of gray, are the palette for this monochromatic layout. An inked library pocket holds support photos. The journaling block, decorated with a gingham ribbon and spiral clip, tells the tyke's story. The metal "Pay Toilet" sign and dangly beads complete the page.

"Honesty, Kass. I thought you were going to wind up going to college in diapers! It seemed like it took me forever to potty train you, but once you were day-trained, you night-trained yourself!"

Carrie Zohn

Carrie Zohn

Look, See!

A heritage feeling is brought to this scrapbook page through the use of "antique" patterned newspaper, stained-looking supporting patterned paper and a black-and-white photo. Tags spell out the page title. A twill ribbon supplies journaling and brads add a touch of metallic gleam to the layout.

Make the Most of Your Photos

For a heritage feeling, print your modern photo in black-and-white. Scrapbook it on distressed, chalked and inked layered papers. Add a shine of ageless metal as embellishment.

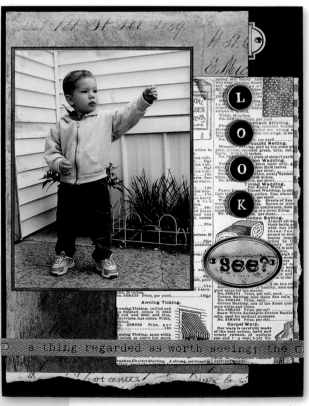

Susan Easley

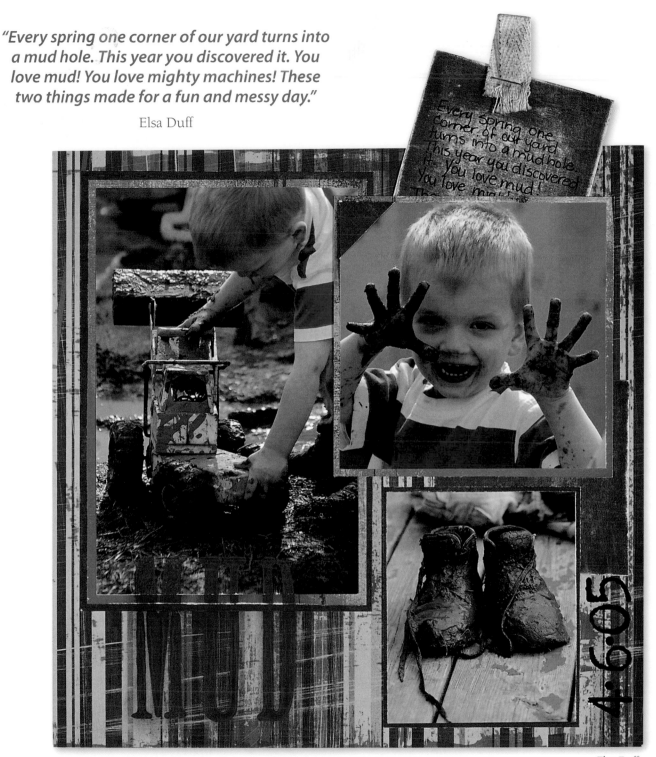

"Every spring one corner of our yard turns into a mud hole. This year you discovered it. You love mud! You love mighty machines! These two things made for a fun and messy day."

Elsa Duff



Elsa Duff

x

x

Mud

Mucky mud makes a wonderful topic for boy page because what boy can turn his back on the opportunity to get dirty? Scrapbook mud play photos on earth tone patterned paper. Stamp a title with paint and then add a layer of chalk over it. Once dry, sand off a portion of the chalk to achieve a muddy look. Tuck a journaling tag behind one of the photos and finish the page off with rub-ons.

x

x

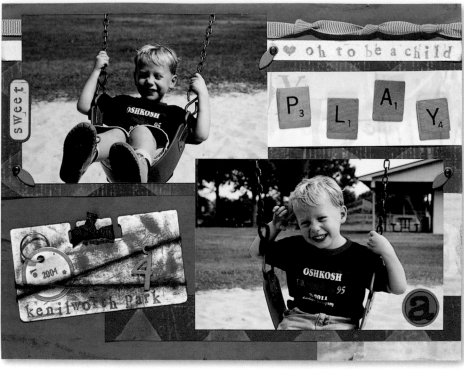

To Be a Child

Game board letters spelling out the word "play" sum up a child's day in the park. Although the page is embellished with ribbon, fibers, photo turns, stickers, tags and charms mounted to a Rolodex card, it is the photos that make the page special. They convey the child's pleasure in soaring through space on a swing.

Tara Daigle

Dressed for Wet

Put a 2-year-old in a room where there is water and you've got hours of good clean fun. Photos of the good times are displayed on this page that is energized by the vibrant patterned paper and the child's bright yellow slicker. Sticker letters spell out the title and adorn the necklace of ribbon-embellished circles beneath the pictures. A stitched pattern defines the top and bottom of the page.

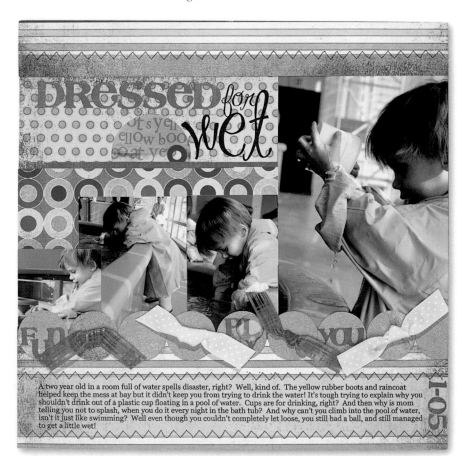

A two year old in a room full of water spells disaster, right? Well, kind of. The yellow rubber boots and raincoat helped keep the mess at bay but it didn't keep you from trying to drink the water! It's tough trying to explain why you shouldn't drink out of a plastic cup floating in a pool of water. Cups are for drinking, right? And then why is mom telling you not to splash, when you do it every night in the bath tub? And why can't you climb into the pool of water, isn't it just like swimming? Well even though you couldn't completely let loose, you still had a ball, and still managed to get a little wet!

Marla Kress

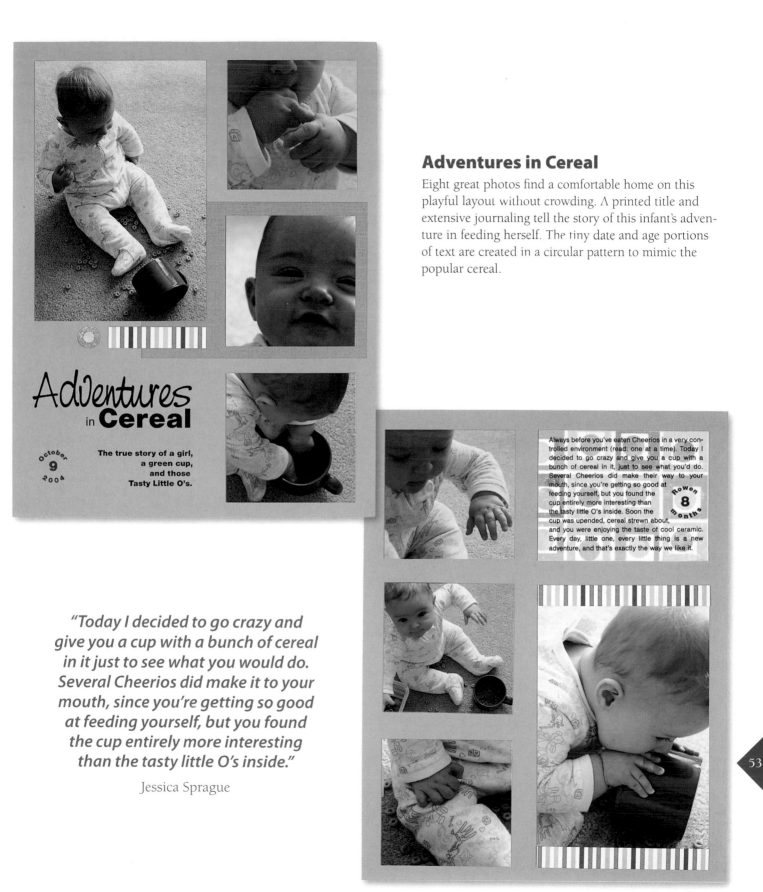

Adventures in Cereal

Eight great photos find a comfortable home on this playful layout without crowding. A printed title and extensive journaling tell the story of this infant's adventure in feeding herself. The tiny date and age portions of text are created in a circular pattern to mimic the popular cereal.

Adventures in *Cereal*

October 9 2004

The true story of a girl, a green cup, and those Tasty Little O's.

Always before you've eaten Cheerios in a very controlled environment (read: one at a time). Today I decided to go crazy and give you a cup with a bunch of cereal in it, just to see what you'd do. Several Cheerios did make their way to your mouth, since you're getting so good at feeding yourself, but you found the cup entirely more interesting than the tasty little O's inside. Soon the cup was upended, cereal strewn about, and you were enjoying the taste of cool ceramic. Every day, little one, every little thing is a new adventure, and that's exactly the way we like it.

Rowen 8 months

"Today I decided to go crazy and give you a cup with a bunch of cereal in it just to see what you would do. Several Cheerios did make it to your mouth, since you're getting so good at feeding yourself, but you found the cup entirely more interesting than the tasty little O's inside."

Jessica Sprague

Jessica Sprague

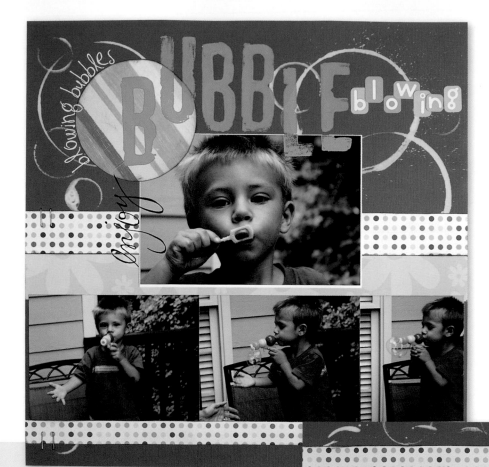

Blowing Bubbles

Bubbles, bubbles are everywhere on this layout that pops with enthusiasm! The circular shape is repeated in the layered patterned papers and the circular paper platform under the first portion of the title. A stamped title and rub-on words provide much of the journaling. An additional funky journaling block gives thanks to a cool grandma who knows just what to plan on a hot summer day.

Making the Most of Your Photos

When mounted side-by-side on a scrapbook page a sequence of photos tells the story of an on-going experience. Take more photos than you believe you will need. Cull out those that seem repetitious, and align the remaining pictures in logical order.

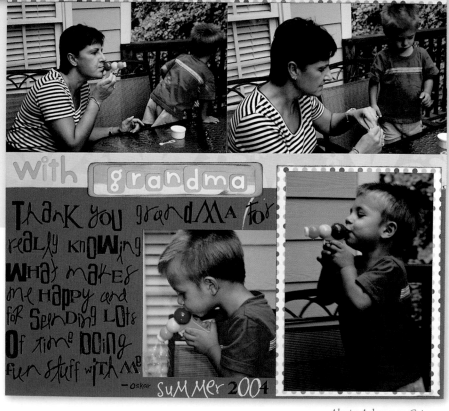

Alecia Ackerman Grimm

"You're never ready to leave the sandbox and you always end up crying when it is time to go home for the day. If you're having a bad day it's nice to now that I only have to bring you to the sandbox to make everything better."

Michelle Tardie

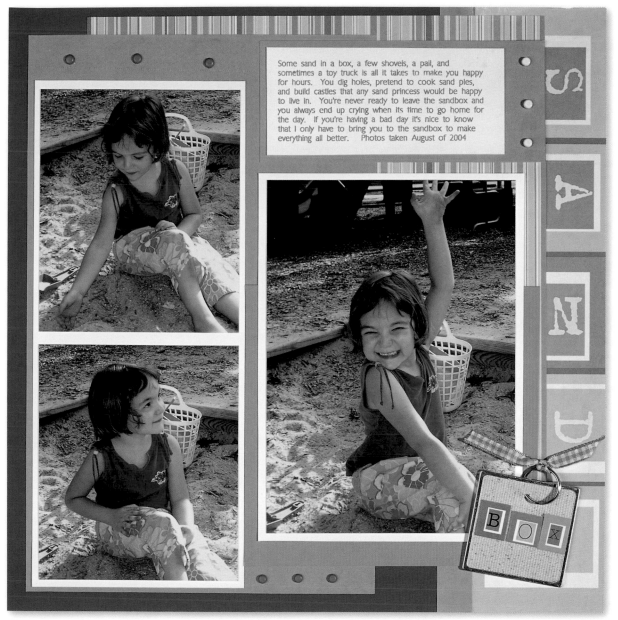

Some sand in a box, a few shovels, a pail, and sometimes a toy truck is all it takes to make you happy for hours. You dig holes, pretend to cook sand pies, and build castles that any sand princess would be happy to live in. You're never ready to leave the sandbox and you always end up crying when its time to go home for the day. If you're having a bad day it's nice to know that I only have to bring you to the sandbox to make everything all better. Photos taken August of 2004

Michelle Tardie

Sand

Sand is one of a child's more flexible toys, cooperatively morphing from a castle to grainy pudding or fairy dust in nothing flat. Capture your child's glee in sand play on a page with layered patterned paper and cardstock. The "n" in the stamped title word, "sand" appears to have been knocked on its side during play. A square tag with letter stickers completes the title. Brads and ribbon adorn the page.

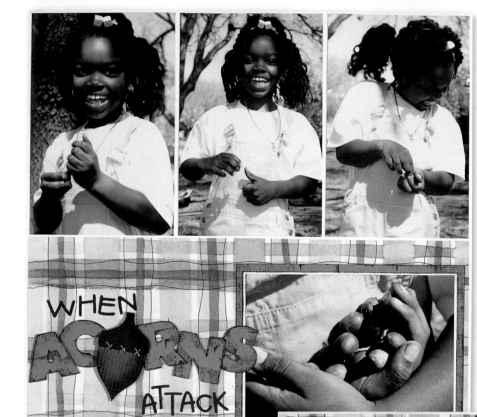

When Acorns Attack

Acorns may roast by an open fire around Christmas, but at other times there are better uses for these versatile nuts! Like snowballs, they are perfect for fun and funny fights. These good-time photos are displayed on earth toned patterned paper. Stickers, an inked title, ribbon and a journaling block add to the layout.

Make the Most of Your Photos

When an event involves interaction between several people, photograph all of those participating. Take pictures of both the action and the reactions to put the story in true perspective.

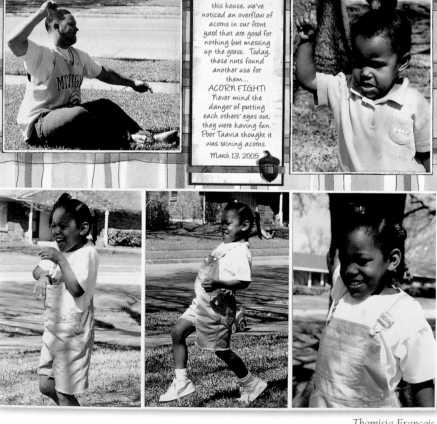

Since we moved in this house, we've noticed an overflow of acorns in our front yard that are good for nothing but messing up the grass. Today, these nuts found another use for them...
ACORN FIGHT!
Never mind the danger of putting each others' eyes out, they were having fun. Poor Taavia thought it was raining acorns.

March 13, 2005

Thomisia Francois

> *"We played in the back yard all day and when the girls found a ladybug, it was like they were the very first kids to ever discover such a creature. I will remember the simple beauty of this day forever."*
>
> Laura Alpuché

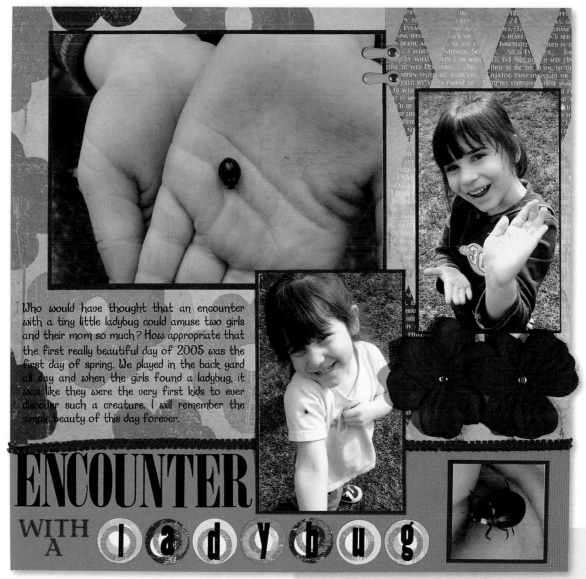

Laura Alpuché

Encounter With a Ladybug

A little thing like the discovery of a ladybug can make the difference between a blah afternoon and one that will be remembered as special. It can also be the inspiration for a memorable scrapbook page. Patterned papers support photos matted with red cardstock. Sticker and rub-on letters form the page title and journaling. Ribbon and baby blue photo turns join vibrant red flowers as embellishments.

Make the Most of Your Photos

It seems only natural to make people the focus of a scrapbook page, but when the true focus of the moment is a bug (or some other object or animal) allow it to take center stage. Move in for a super close photo, enlarge the shot and use those "people pictures" to support your focal image.

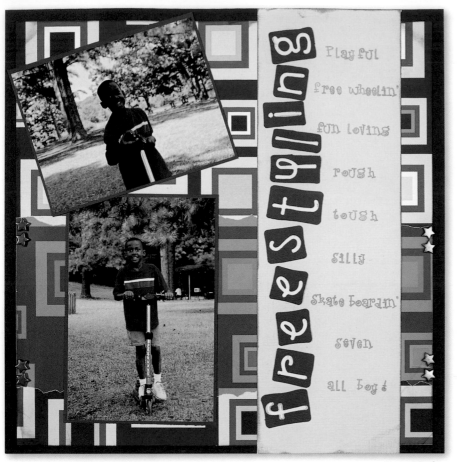

Renee Hagler

Freestyling

Somebody is playful, free wheelin', rough, tough, and all boy. That "somebody" is featured in the photos on this page. A strip of vellum is mounted over patterned paper and blue textured cardstock. The alphabet blocks and stamped words convey the theme of the piece. Tiny star snaps say that this little guy is, in fact, a rising star.

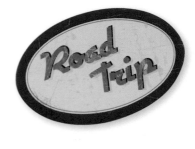

Spring Fever

A collection of brilliantly colored photos sit against vibrant patterned papers on this energetic layout. The title picks up the colors within both papers and photos. Blue brads and fiber finish off this piece.

"March came in like a lion last week with a big ol' snowstorm. And now, this week, it's going out like a lamb, and we can't wait to roll on pavement. This isn't a sled under Isaac, it's a skateboard...So, come on spring, we're ready."

Deborah Hodge

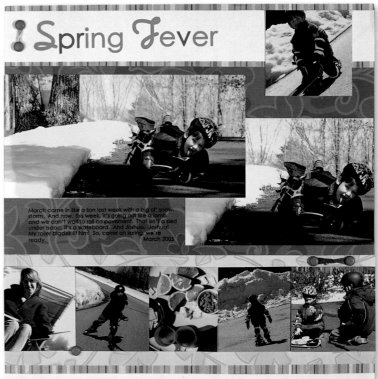

Deborah Hodge

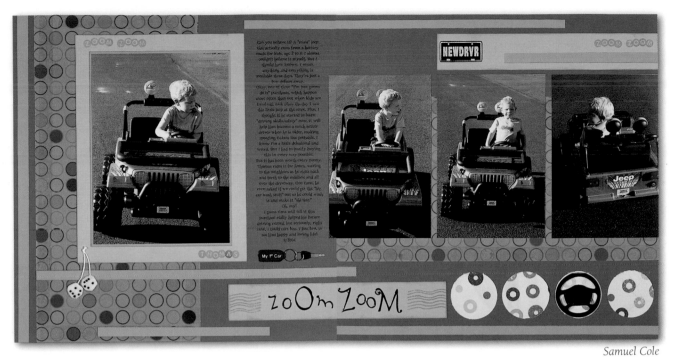

Samuel Cole

Zoom Zoom

Watch out drivers, here this little guy comes in his very own mini car! Scrapbook speedy photos on colored paper and cardstocks. A tiny key ring embellishment, stickers and extensive journaling make the page.

"Oh my! I guess time will tell if this purchase really helped his future driving record, but seriously, right now, I could care less. I just love watching him happy and loving life!"

Samuel Cole

Spring Break

Going. Going. Energy is now officially GONE. Spring break can take a lot out of a kid, as these photos illustrate. Scrapbook on-the-go photos on white waffle-weave paper. The journaling text boxes are turned in all directions. Subtitles are printed in a variety of fonts, cut into blocks, inked and mounted amidst the text. A bold stencil letter is wrapped with twine and embellished with a themed tag and brads. A "boys and their toys" token sums up the page.

"Spending time with Dylan means lots of laughs, silly conversation, jokes, X-box, flaming hot Cheetos and playing outside."

Renae Clark

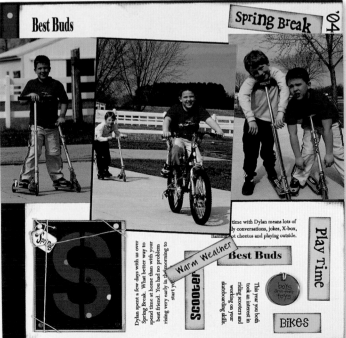

Renae Clark

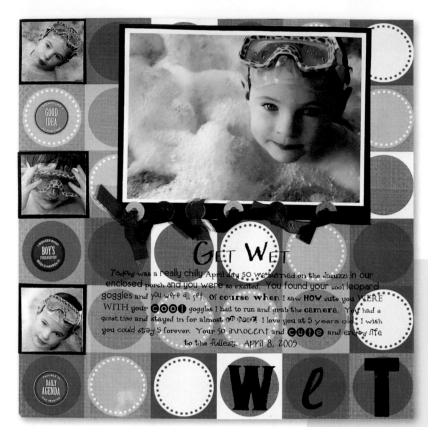

Get Wet

A dip in a foamy jacuzzi on a chilly April day seems just the recipe for this five-year-old. Photos are matted on black cardstock and again on patterned paper. Coasters support humorous messages. Bright colored ribbons are strung along the bottom of the focal photo mat. A stamped phrase balances the lower right corner of the page.

Make the Most of Your Photos

Matting light colored photos on black paper gives them a foundation and makes the pictures seem to visually advance. Use this technique when you are concerned that your photos may be overwhelmed by other page elements.

Martha Crowther

Pool Side

Coordinating patterned papers can make a scrapbooking job come together in nothing flat. Here, mesh paper is laid over a distressed paper background and nestled next to a polka-dot swath of patterned paper. A tag in the same shades declares the page title with sticker letters. Stamped words, photo turns and a bookplate as well as a yellow button and shiny brad complete the summery scene.

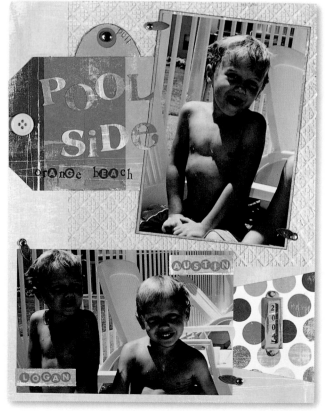

Tara Daigle

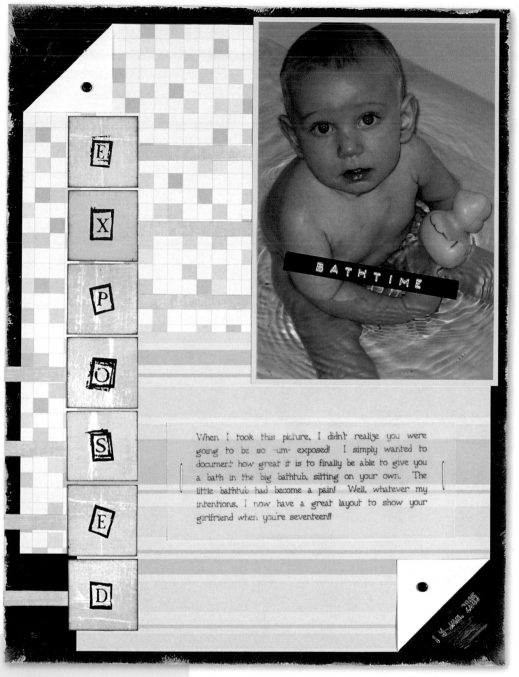

When I took this picture, I didn't realize you were going to be so -um- exposed! I simply wanted to document how great it is to finally be able to give you a bath in the big bathtub, sitting on your own. The little bathtub had become a pain! Well, whatever my intentions, I now have a great layout to show your girlfriend when you're seventeen!!

Claude Campeau

Make the Most of Your Photos

No need to hide away a picture of your slightly "exposed" infant. Instead, use journaling or embellishments to provide the baby with a bit of creative coverage.

Exposed

Bath time is a favorite time of day for most babies and their parents. A photo of a slippery clean infant is superbly scrapbooked on a page of bright yellow patterned papers laid over a lightly painted black cardstock background. A vellum journaling block and stamped title letters tell the story of this little one's somewhat compromising position.

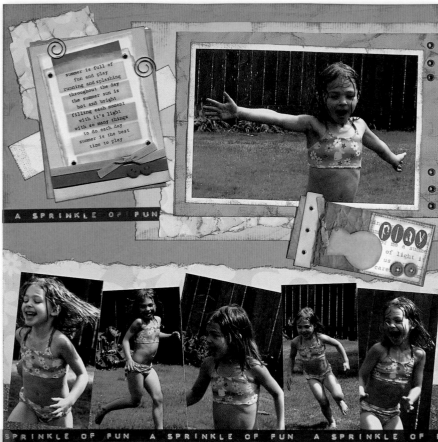

A Sprinkle of Fun

Fun in the sun comes to life on this lively spread. Crumpled and inked papers are mounted on a cardstock background and summery die cuts and paper elements are secured with a heavy sprinkling of tiny eyelets. The title, created with a running message on label tape, flows across both pages in the spread. Buttons, spiral clips and fibers embellish the layout.

Make the Most of Your Photos

Capturing action requires timing on the part of the photographer. Rather than attempting to follow the action through your view finder, position yourself in one place and focus on the space most likely to be filled by your moving target. When she comes into view...snap.

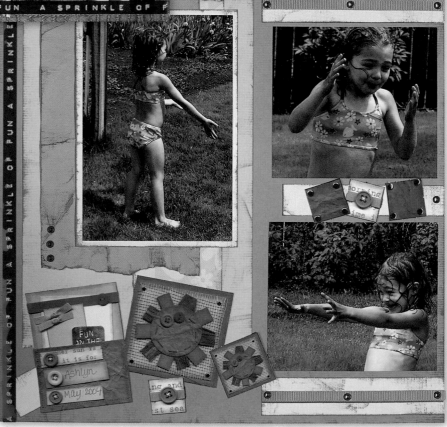

62

Raechelle Bellus

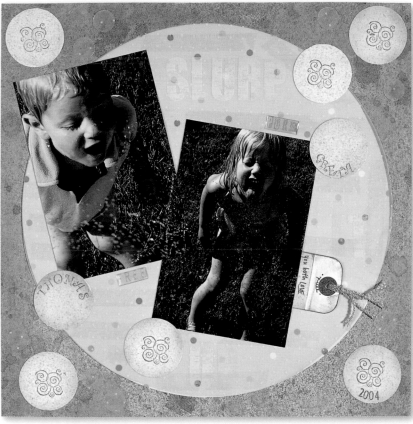

Samuel Cole

Slurp it Up

It's not as easy as it looks...taking a drink from a sprinkler or hose. But that doesn't stop kids from trying. Capture their attempts in photos and scrapbook them on a page that repeats the shape of the circular water droplets again and again. Stamp circular shapes. Journal on a fiber-tied tag and slip it behind one of the photos. Stamp the title around the edges of your circular photo mat.

Cool New Haircut

Careful there! You don't want to get that spiffy new haircut wet! Or at least not until Mom takes your picture! Mount terrific photos like these on cardstock and patterned paper backgrounds. Swipe arbitrarily with paint. Decorate with tiny flowers, punched circles, word stickers and brads. Create the title with white paint and a lettering template.

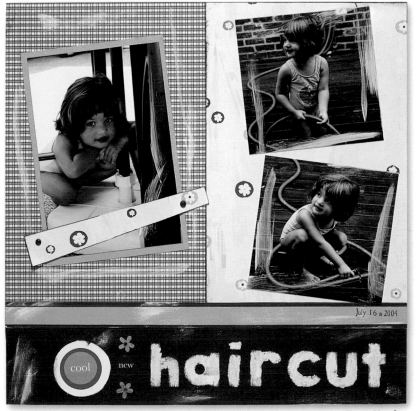

Tracy Kuethe

"When you are creating you are very serious and sometimes you sing or whistle to yourself (just like your great papa!) and it is so cute. When you are finished you are so proud to show off your creation and test it out. I just love seeing what your creative little imagination comes up with everyday!"

Miki Benedict

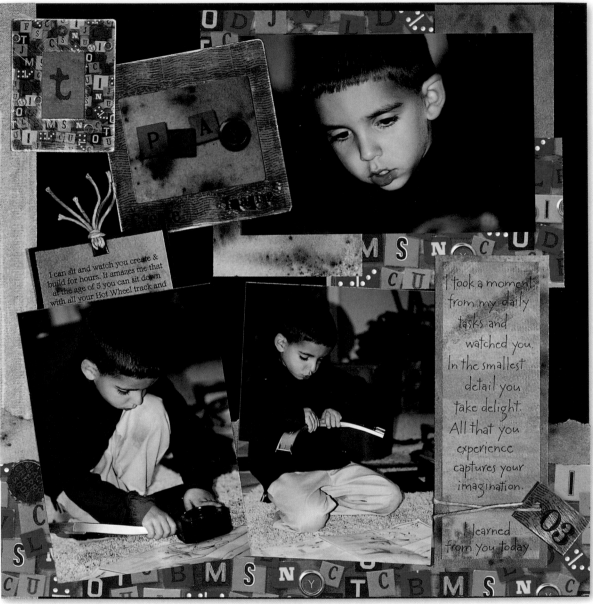

Miki Benedict

Play

Play can be serious work and that concept is conveyed through the contrasting black cardstock and happy-go-lucky patterned papers used on this page. The die-cut slide mounts are pure fun. They have been lightly sanded for a distressed look. Photos of an engineer at work are mounted next to a pertinent sticker quote which is wrapped in fiber and bears a stamped date tag. Journaling is written on a tag that is slipped behind one of the support photos.

One Photo Two Ways

Digital photography was just a start for many of today's scrapbook artists. While some use their computers to manipulate photos and write text blocks, others are seeking ways to get more use from their software. They are creating digital papers for layouts and embellishments that seem as dimensional as a traditional paper layout.

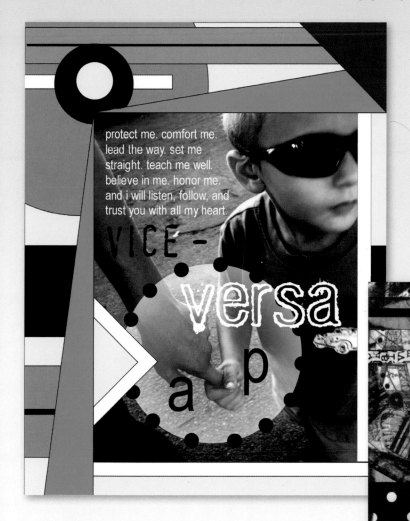

Vice Versa

Traditional scrapbook papers are brought together in an arresting design for this artistic photo. Words typed on a transparency are overlaid to supply both journaling and title.

Vice-Versa

How far can you push digital? Pretty far! And this artist has proven it. The paper, embellishments and photograph on this page have all been created with computer software. Opacity has been altered to give the text a sense of dimension. Texture is created with the faux corrugated cardboard bordering the photo on the left. The label tape, heart embellishment and all other features of the page are one dimensional.

Amber Clark

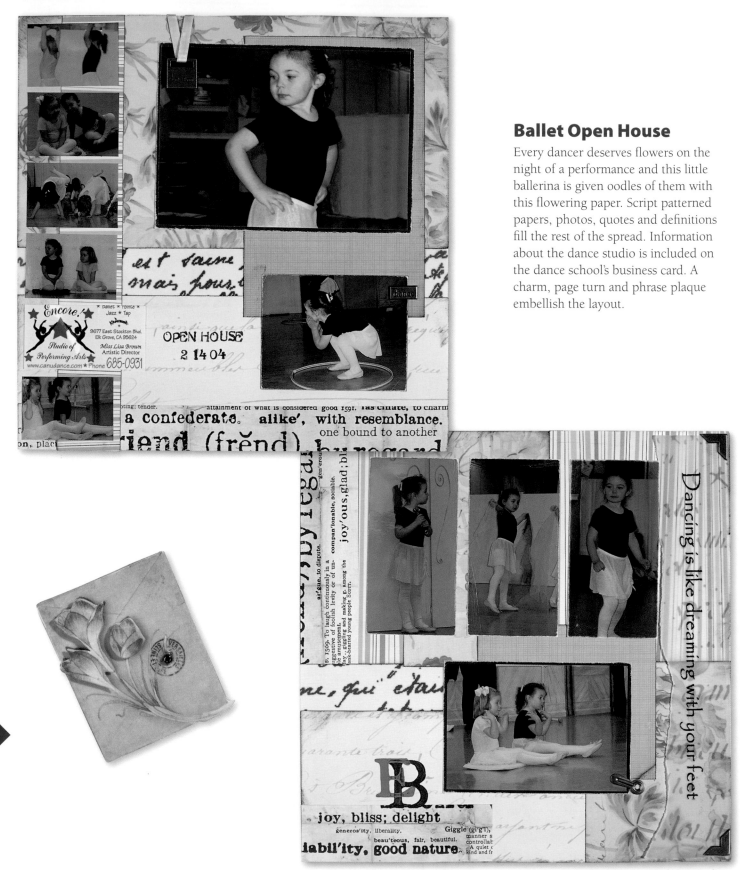

Ballet Open House

Every dancer deserves flowers on the night of a performance and this little ballerina is given oodles of them with this flowering paper. Script patterned papers, photos, quotes and definitions fill the rest of the spread. Information about the dance studio is included on the dance school's business card. A charm, page turn and phrase plaque embellish the layout.

Catherine Bodine

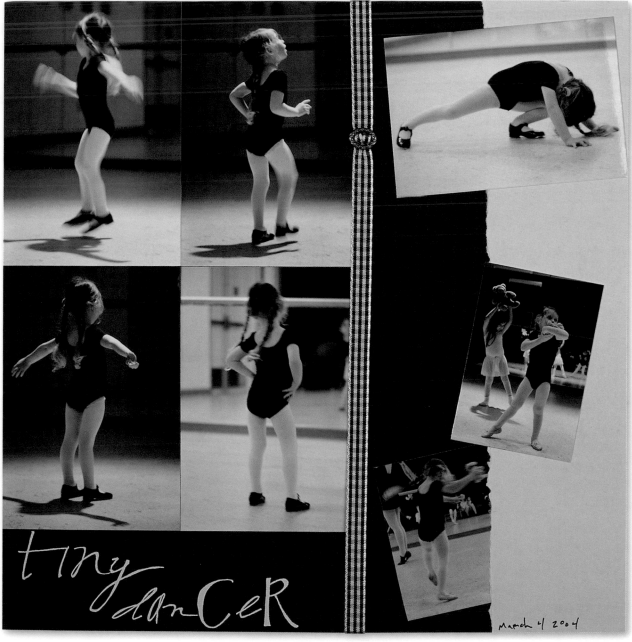

Tracy Austin

Tiny Dancer

Photos tell the story so beautifully on this page that there is little need for either text or embellishments. The series of pictures, taken at a slow shutter speed, captured the tiny dancer in mid-motion. Every attitude and posture seems to be real and raw, giving the layout its appeal. Black and pink card-stocks, a title formed by mixing and matching rub-on letters and a buckle-strung ribbon bring down the house.

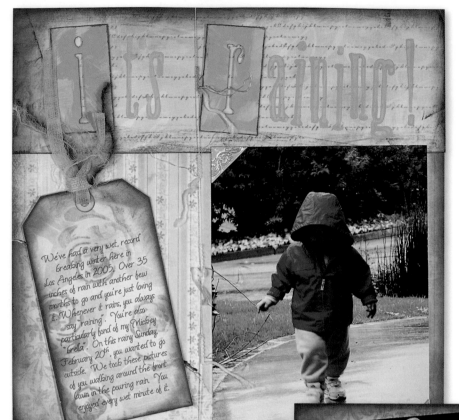

It's Raining

It's raining, it's pouring the old man is snoring...but this little girl is wide awake and puddle jumping. Photos of her fun are scrapbooked on layers of beautiful patterned papers. Jigsaw alphabet pieces and stamped letters make up the title. Journaling appears on the fiber-strung tag. Rub-on words adorn the tag on the right side of the spread. Additional fibers are wrapped around a swirl heart and decorative photo corners add embellishment to the focal photo.

"Whenever it rains, you always say "raining." You're also particularly fond of my Mickey "brella." ...We took pictures of you walking around the front lawn in the pouring rain. You enjoyed every wet minute of it."

Julie Gelfand

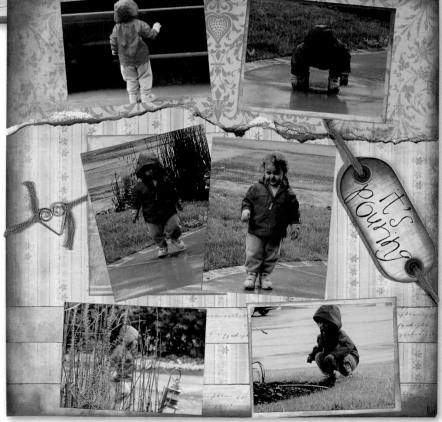

Julie Gelfand

It's Not As Hard As It Looks

Use double-sided paper as your page background. Create the accent circles by punching circles in the background paper. Mount the entire piece of decorative paper (which has been laced and on which photos have been mounted) on cardstock. Turn the punched shape over and put it back in the hole from which the shape was removed.

Create dimension by using a hole punch to create holes on the circular patterns. Lace fibers through the holes.

Eliminate the need for a photo mat by swiping the edges of your photo with acrylic paint.

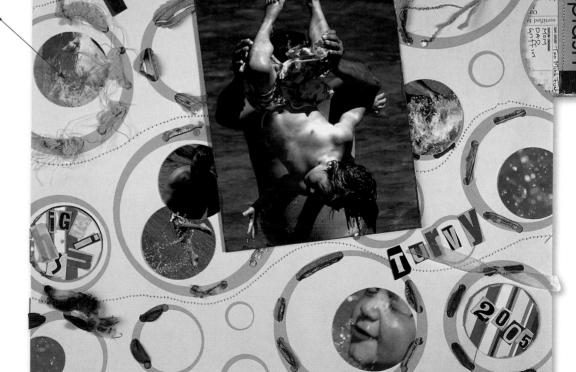

Laura McKinley

Topsy Turvey

Lively patterned paper creates a sense of motion for this active page. The circular patterns on the paper provide frames for circle-cropped photos. Accent circles of patterned paper are mounted inside larger circle shapes. Journaling is created with stickers. The focal photo, mounted directly to the background paper, captures horse play in motion.

Make journaling words by cutting rectangular cardstock word stickers down to size. Mount them on paper circles and use a circle punch to round the edges.

The wide world lies right outside our doors, just waiting to be explored. From seashore to mountains and on to flower strewn rolling hills, the great outdoors provides locations for beautiful photos. Panoramic views of nature at her best can be colorful and heart lifting, as are pictures of our interaction with the world surrounding us. Scrapbooking out-and-about photos can result in art that captures the best of nature and our special relationship with her.

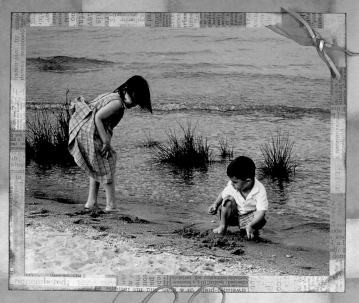

Youthful Hearts

The search for shells and other treasures along the shore can fill the long, lazy days of summer with magic. This quick-and-easy spread takes advantage of both beautiful paper and stunning photos, requiring only the simple embellishment of brads, a stencil tag and ribbon.

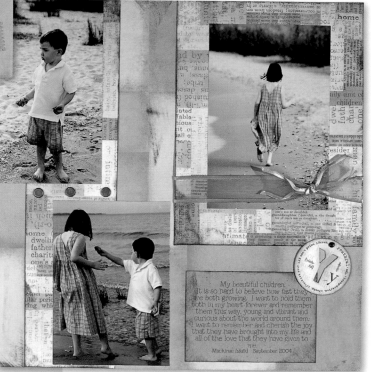

Make the Most of Your Photos

Often the best photos are made without saying "cheese." Capture those precious childhood moments by stepping back, camera in hand, and wait. The right moment to make a photo will present itself in time.

Debbie VanMarter

Skipping Stones

This clean and compelling layout derives its emotional power from the sky blue textured cardstock. An oversized photo is mounted off center and two additional matted photos are mounted directly on top. A twill tape sticker and rub-on title letters embellish without muddying the design.

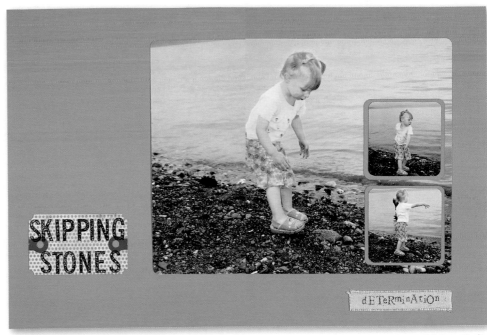

Melissa Godin

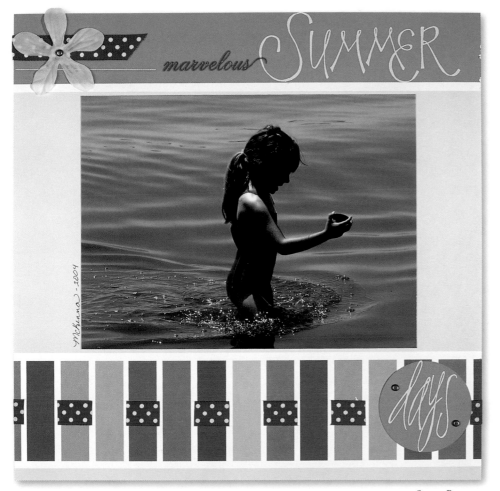

Marvelous Summer

A pristine beach, a beautiful child, a treasure from the deep...a photo that captures all of this should be scrapbooked on a page as simple and elegant as possible. Cool blue cardstocks frame the photo and create a border along the bottom of the page. A vibrant red ribbon is laced through the border and a tag of ribbon appears under the flower embellishment at the top of the page. Rub-on letters form the title and brads embellish.

Sonya Breaum

71

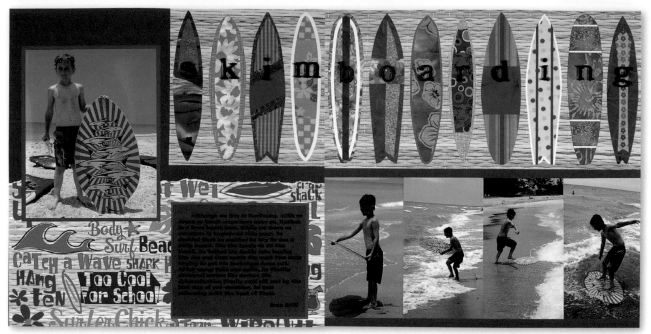

Skim Boarding

Beach patterned paper makes this bright spread super easy to create. Photos are matted on blue and red cardstocks. Sticker letters are used to create the title. Substantial journaling tells the story of a land-bound child at the sea.

"While we were on vacation in Englewood this year, he decided that he wanted to try to use a skim board like the locals do at the beach...His determination finally paid off and by the last day of our vacation, he was skimming with the best of them."

Nancy Boyle

Feet in the Sand

Transparent letters forming the page title are painted to match the upbeat ribbons and fun patterned papers on this page. Paper flower embellishments, a phrase charm, metal bare feet and rollicking buttons carry on the fun.

"Feet in the sand—I don't think there is a better feeling than that. The incredible sensation of your feet and toes in the cool sand. They start to sink as water comes in and surrounds them. Soon your toes are completely covered..."

Julia Sandvoss

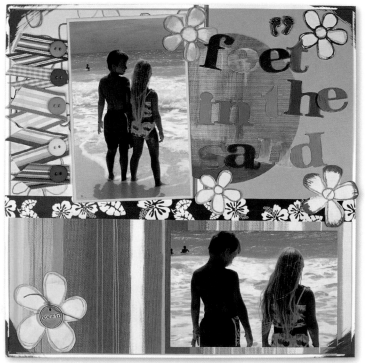

BEACH at the

what is it about sand that is so fascinating? and sea-shells by the seashore? Dylan is no exception to the rule. we cannot dig in the sand enough or find too many shells for our collection..... i guess it could be worse. we could be collecting worms and slugs. pix 05/03 - added review 01/04

"I dug in the sand and I carefully made five sand castles with my pail and spade. I felt like a kid in a golden crown until that blue sea washed my sand castles down. So I dug again by the sandy shore until I had TEN sandcastles and was King once more!"

Kris Gillespie

Catchin' Some Rays

A clean white background accented with boldly colored striped patterned papers, a title created with stamps and rub-ons and five terrific action photos make this spread something to remember. Sticker fish swim along the left side of the focal photo. The crowning touch? The stamped word directly on the focal photo!

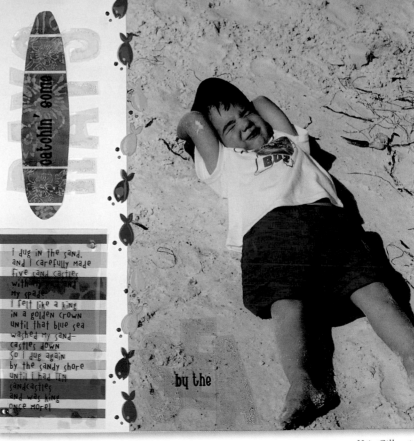

catchin' some RAYS

i dug in the sand. and i carefully made five sand castles with my pail and my spade. i felt like a king in a golden crown until that blue sea washed my sand-castles down. so i dug again by the sandy shore until i had TEN sandcastles and was king once more!

by the

Kris Gillespie

73

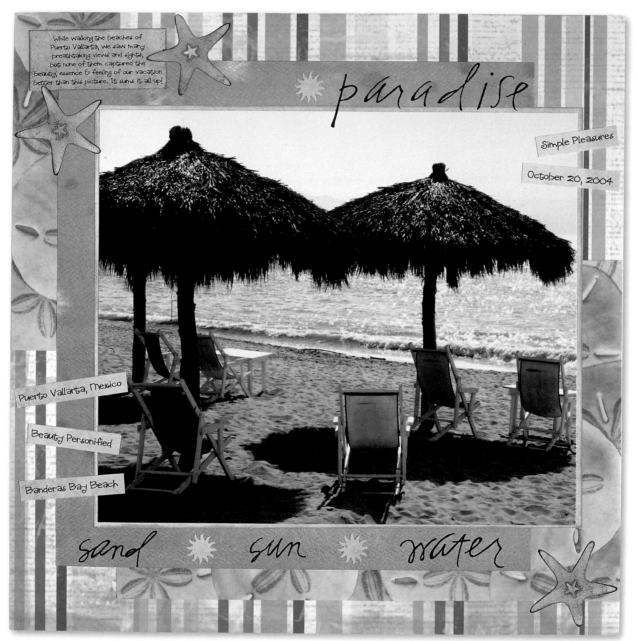

While walking the beaches of Puerto Vallarta, we saw many breathtaking views and sights, but none of them captured the beauty, essence & feeling of our vacation better than this picture. It sums it all up!

paradise

Simple Pleasures

October 20, 2004

Puerto Vallarta, Mexico

Beauty Personified

Banderas Bay Beach

sand ☀ sun ☀ water

Samual Cole

Paradise

Not a soul in sight...just sand, sun, chairs begging to be filled and the sound of the surf. Paradise. Scrapbook photos of paradise on pastel patterned papers. Partially mat the photo on blue paper. Embellish with paper starfish and create a title and journaling with rub-on words and journaling strips.

"While walking the beaches of Puerto Vallarta, we saw many breathtaking views and sights, but none of them captured the beauty, essence and feeling of our vacation better than this picture."

Samual Cole

Postcards

Having fun. Wish you were here... This simple page featuring postcard patterned paper, globe patterned paper and card-stock conveys the sentiment simply and cleanly. Fibers hold together the portioned photo frame and string laced through a journaled strip at the bottom of the page serves as a border. The postcard provides a platform for journaling.

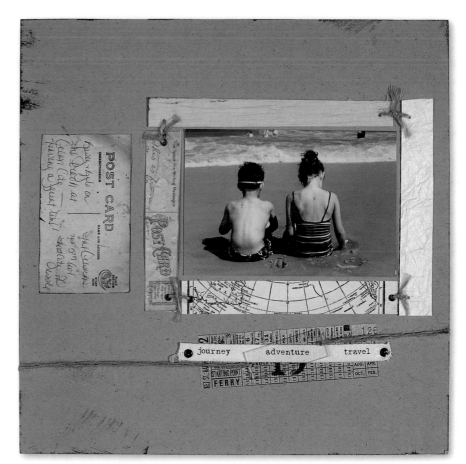

Donna Oresick

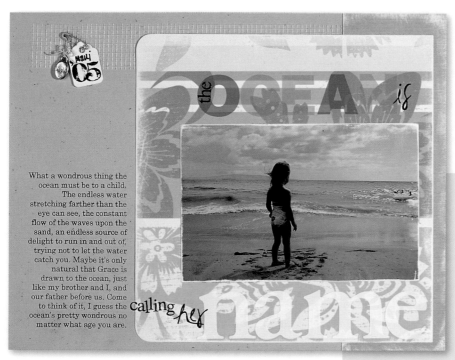

Heather Thompson

The Ocean

"What a wondrous thing the ocean must be to a child," reads the journaling on this dreamy page. Pastel colored patterned paper matted against a sand colored background, rub-on words and a delicately embellished tag held in place with a safety pin support the photo.

Make the Most of Your Photos

Every actor knows that posture conveys a strong message about character and circumstances. Even when his back is turned to the audience, he is communicating. In the same manner, photos taken from behind a model can capture and convey the essence of a scene beautifully. It isn't always necessary to photograph people head-on.

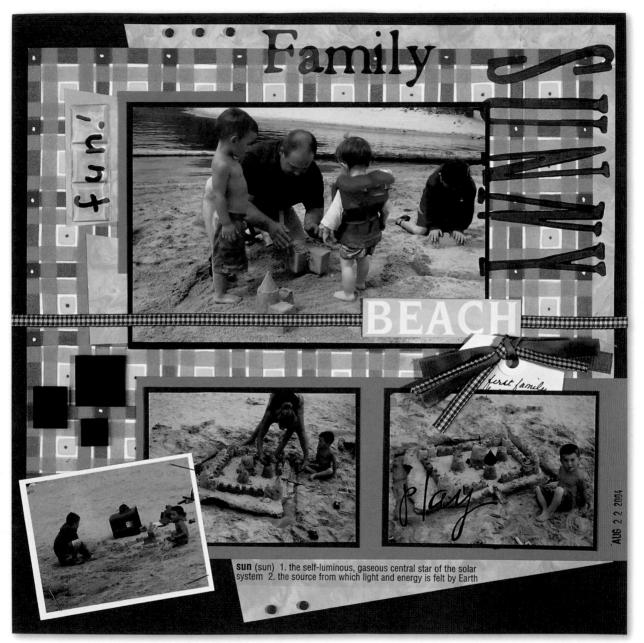

Aimee Grenier

Family

Restful hours on the beach are perfect for bonding and sharing a common goal—the building of a castle. These photos record those good times. Scrapbook them on patterned paper and yellow and blue cardstocks. A stamped title, rub-on words, ribbons, brads and a paper clip join tags to celebrate the fun.

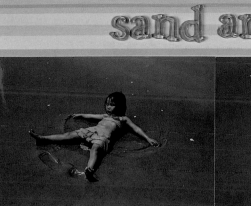

sand angel

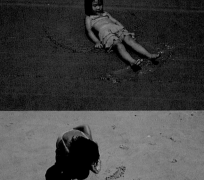

If you can make snow angels in the winter, why not make sand angels on the beach in the summer? Abby gave it a try one afternoon when she, Jenny, and I went for a walk up the beach. Sand turns out not to be such a good medium to leave an angel impression in. However, sand turns out to be wonderful to write in! Sand also can be wet and gloopy and fun to play in with your feet! Who says that sand is just for building sand castles? (Photos June 2004; journaling August 2004)

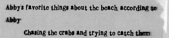

Sand Angel

Shell colored patterned transparencies and a collection of peaceful photos set the mood for this beach spread. Stickers are used to make the border on the left and real buttons are attached directly above the button shapes on the stickers. Icicle letters at the top of the same page form the title. Extensive journaling tells the story of this girl's beach time experience.

"If you can make snow angels in the winter, why not make sand angels on the beach in the summer? Abby gave it a try one afternoon when she, Jenny, and I went for a walk on the beach."

Deborah Taub

Abby's favorite things about the beach according to Abby

Chasing the crabs and trying to catch them
Getting hot
Digging in the sand
All the things there are to do
Jumping in the waves
Holding Mommy's hand in the ocean
Dolphins — they are pretty and they are silver
Boats
The sky
The ocean
I want to do that again

Sand
Sea
Sun

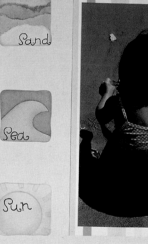

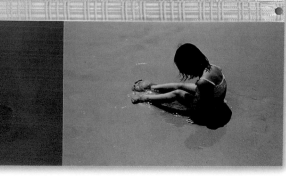

Deborah Taub

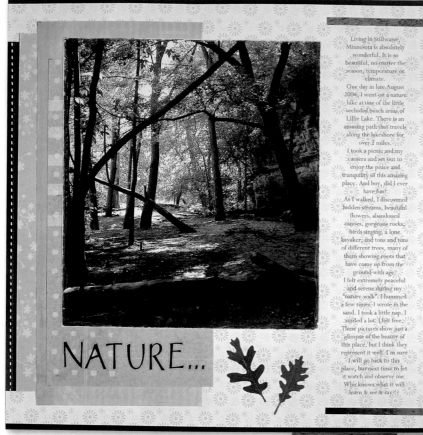

Living in Stillwater, Minnesota is absolutely wonderful. It is so beautiful, no matter the season, temperature or climate.

One day in late August 2004, I went on a nature hike at one of the little secluded beach areas of Lillie Lake. There is an amazing path that travels along the lakeshore for over 2 miles.

I took a picnic and my camera and set out to enjoy the peace and tranquility of this amazing place. And boy, did I ever have fun!

As I walked, I discovered hidden streams, beautiful flowers, abandoned canoes, gorgeous rocks, birds singing, a lone kayaker, and tons and tons of different trees, many of them showing roots that have come up from the ground with age.

I felt extremely peaceful and serene during my "nature walk". I hummed a few tunes. I wrote in the sand. I took a little nap. I smiled a lot. I felt free.

These pictures show just a glimpse of the beauty of this place, but I think they represent it well. I'm sure I will go back to this place, but next time to let it watch and observe me. Who knows what it will learn & see & say?!?

NATURE...

Nature

From forest to rocky ridges and sandy shores, nature is breathtakingly beautiful. Take the time to explore her glory and take along your camera. Scrapbook photos on a clean spread that features an extensive journaling block. Neatly matted photos and stamped embellishments keep the layout clean and precise.

"I took a picnic and my camera and set out to enjoy the peace and tranquility of this amazing place. And boy, did I ever have fun! As I walked, I discovered hidden streams, beautiful flowers, abandoned canoes, gorgeous rocks, birds singing, a lone kayaker and tons and tons of different trees..."

Samual Cole

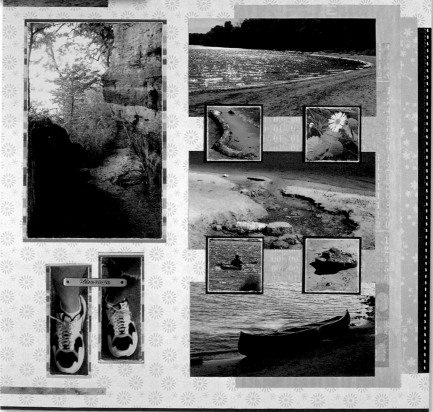

Samual Cole

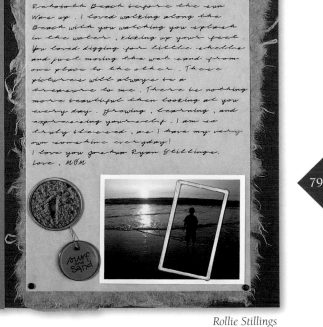

My Son

Striking photos of a young boy greeting the morning are scrapbooked on light brown cardstock and script paper. An overlay on the focal photo supplies a poetic quote. The journaling block is matted on mulberry paper. At the bottom of the journaling block, a support photo is featured in a metal frame. The center is removed from a vellum tag and a picture of a footprint in the sand is inserted. Rub-on words supply journaling on the images mounted on top of the script paper. Alphabet pebbles and squares, as well as brads add dimension to the layout.

"Today I woke up and looked over and there you were staring back at me. I said to you, "Would you like to go to the beach and watch the sunrise?" You answered with a nod and a smile. So off we went down to Rehoboth Beach before the sun was up..."

Rollie Stillings

Rollie Stillings

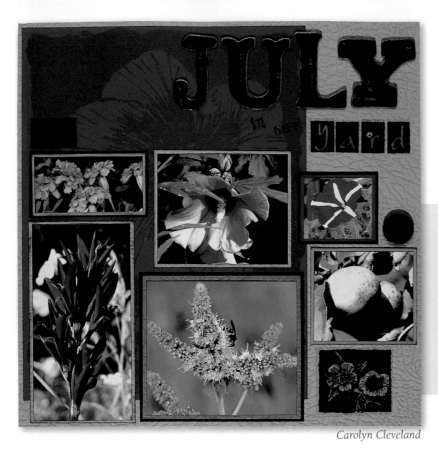

July in Our Yard

Sometimes photos are so perfectly beautiful that words and embellishments only detract. These photos convey the sense of summer in full bloom. Patterned papers support the images. Chipboard title letters and stickers supply information without getting in the way of the pictures.

Carolyn Cleveland

Make the Most of Your Photos

Human models are not the only images worthy of photographing. Close-ups of flowers, fruit and foliage can take center stage, resulting in a scrapbook page that is rich with color and visual texture.

The Closest Inspection

Close up and personal, nature is a world unto itself, as discovered by this youngster. The supporting photo border along the right side of the page provides viewers with a measure of what the child is enjoying. A simple poetic quote, a ruler ribbon and tiny tag complete the scene.

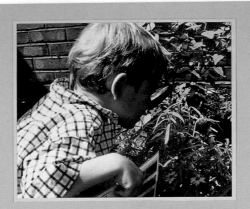

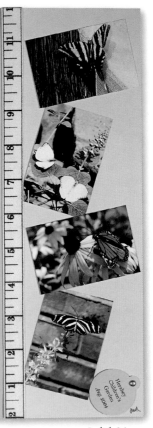

Nature will bear

the closest inspection.

She invites us to lay our eye
level with her smallest leaf,
and take an insect's view
of her plain.

Henry David Thoreau

Judith Mara

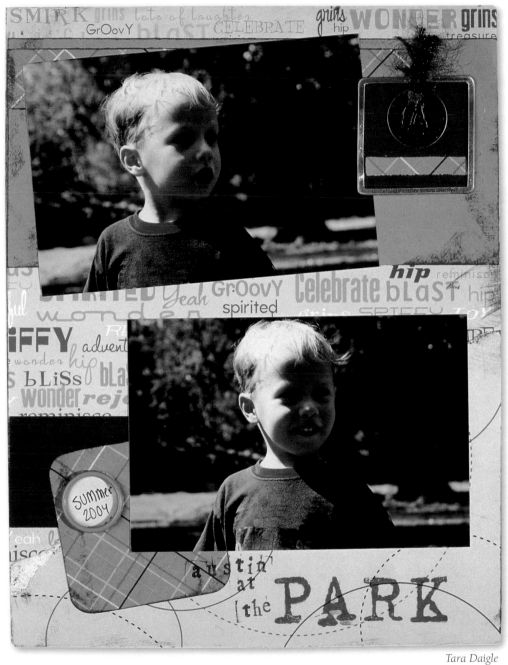

Tara Daigle

Austin at the Park

Freedom for a young boy is a day at the park with nothing to do but run and climb. Showcase photos like these on coordinating patterned papers mounted over a brown background. A metal-rimmed tag frames a metal letter and is accented with fibers and a strip of patterned paper. The circular blue tag holds the journaled date. The title words are stamped with brown ink to fit with the earth tone palette.

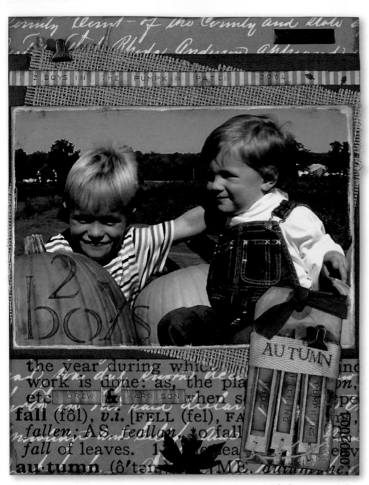

Melodee Langworthy

2 Boys

What is it about piles of pumpkins that makes moms race for the camera? Maybe it is their brilliant orange color, or maybe it is because children seem to find posing on them fun! Scrapbook those sure-thing October photos with orange patterned papers and green cardstock. Add a transparency over the bottom portion of the page. Mount the over-sized photo on a background of burlap. Emboss the page title directly on the photo. Add a decorative envelope tied with fiber.

She's a Little Bit Country

...and a "Lotta Bit" cute! This quick-and-easy page relies on the quality and appeal of the photo for its success. A swath of patterned paper runs across the bottom of the page, bordered by a strip of coordinating paper. Textured plum cardstock and a ribbon are all that is needed to complete the layout.

"Paige you are such a princess most of the time. Heck, you wouldn't go to gym because your running shoes didn't match your outfit but when I saw you today...I realized you may be a country girl at heart."

Angela Biggley

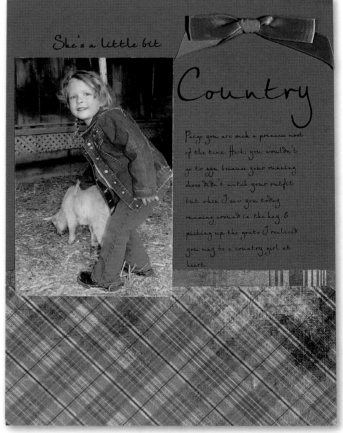

Angela Biggley

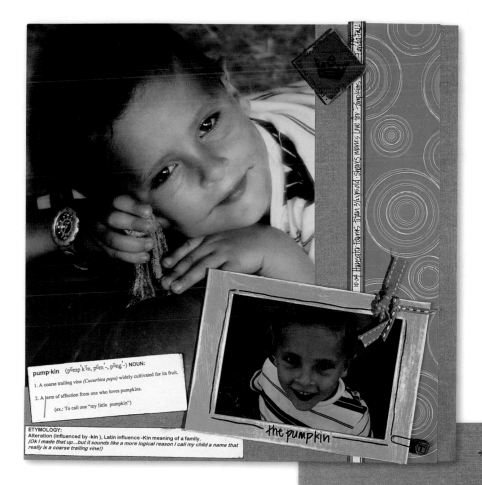

pump·kin (pŭmpʹkĭn, pŭmʹ-, pŭngʹ-) NOUN:
1. A coarse trailing vine (Cucurbita pepo) widely cultivated for its fruit.
2. A term of affection from one who loves pumpkins.
 (ex.: To call one "my little pumpkin")

ETYMOLOGY:
Alteration (influenced by -kin), Latin influence -Kin meaning of a family.
(Ok I made that up...but it sounds like a more logical reason I call my child a name that
really is a coarse trailing vine!)

the pumpkin

The Pumpkin Prince

A fun filled day at the pumpkin patch
is recorded in a series of photos that
capture the action and personality of
this Pumpkin Prince. The focal photo
on the left side of the spread is matted
directly on the green textured cardstock
background. A supporting photo appears
beneath, in a distressed chipboard frame.
Definition journaling, a hand-lettered,
stamped embellishment and ribbons
complete the page. The right side page
in the spread shows a stamped word and
decorative tape.

Make the Most of Your Photos

The digital focal photo on this spread has
been softened with a filter to give the
picture a gentler appearance. It conveys the
concept that after a full day of pumpkin play
the child is now tired and content. Consider
using this technique for photos for which
you wish to convey a sense of relaxation.

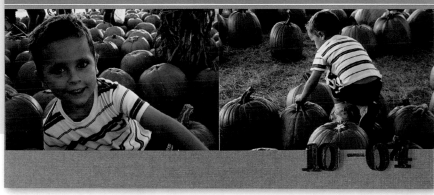

Megan Kulisich

83

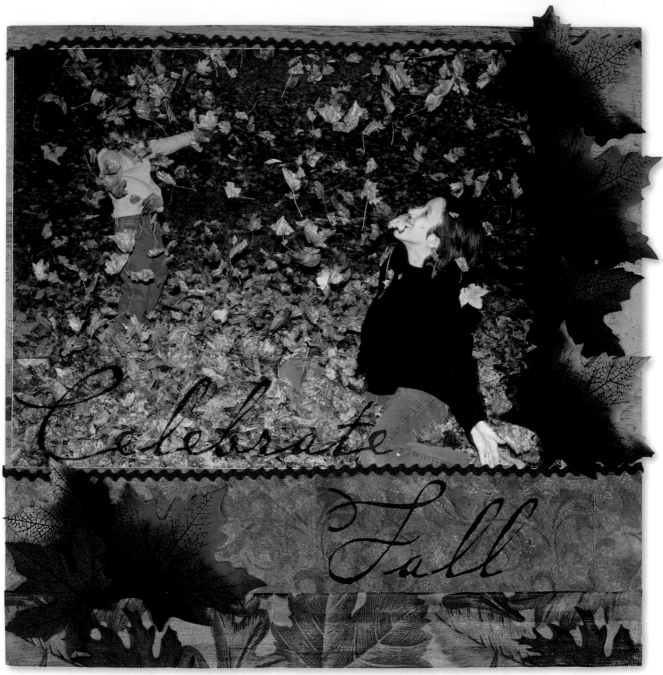

Kim Musgrove

Celebrate Fall

A flurry of leaves and a blanket of crunch beneath booted feet makes autumn one of the most special times of the year. Record the beauty of fall with an over-sized action photo and stunning patterned papers. Use stickers or silhouette cut leaves from patterned paper to mount directly over the edges of the photo. The title is printed on a transparency and mounted over the photo and papers. Strips of rickrack embellish the layout.

Autumn Natural Beauty

The colors of fall can be so vivid and varied. Photograph them in all their glory and scrapbook them in a digital layout. These photos are showcased on digitally created papers. Fonts are varied. They are overlaid and their opacity is varied for visual interest.

"Autumn, the year's last, lovely smile. Our acres of heaven in New Market Township, MN."

Theresa Kavouras

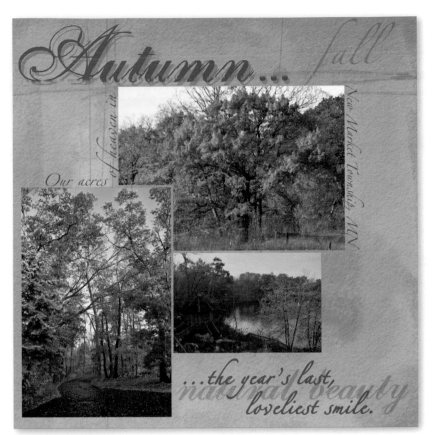

Theresa Kavouras

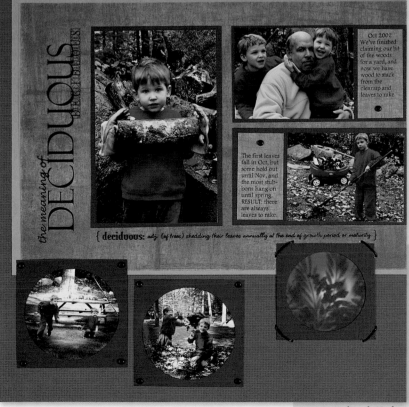

Deborah Hodge

The Meaning of Deciduous

Fall is the perfect time to be outside. There is so much to do—collecting wood, raking and horsin' around in the nippy air. Mat photos of autumn outdoor fun on textured purple cardstock or display them inside punched circle frames. Mount images on decorative vellum and textured green cardstock. Journal and add decorative brads. Paint a nature scene on vellum and mount it behind a punched circle frame.

Make the Most of Your Photos

Use image manipulation software to soften the edges of your photos. The photos in the first two circle frames were vignetted with a circle. Feathering was set to 35 and the edges were desaturated.

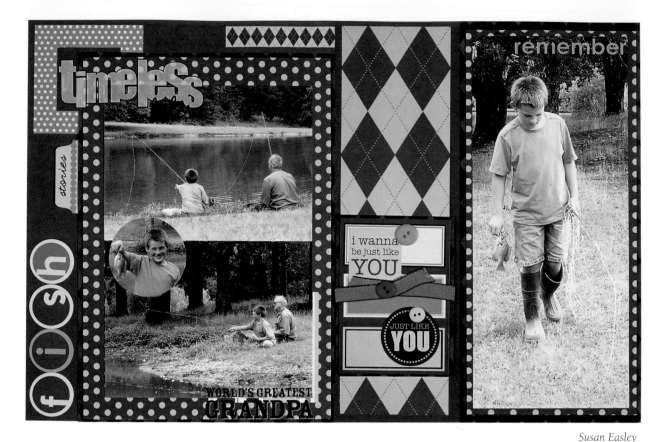

Susan Easley

Fish Tales

Sepia-tone papers give this modern day spread a heritage feel. The earth-tone patterned papers and cardstock reinforce the mellow, laid back experience of a day fishing with Grandpa at the lake. A ribbon-wrapped tag is decorated with buttons. Rub-on words are artfully displayed on the spread. A color photo, cropped to circular shape, displays a proud catch.

Who Doesn't Love Ducks...

Ducks are great entertainers, with their quacks and tail wiggles. Scrapbook boy-meets-ducks photos on patterned paper and textured cardstock that will assure the fun is remembered long after the ducks have floated off to other destinations. Letter stickers form the title and die-cut synonym tabs supply the journaling.

Megan Friesen

"You are blessed to have a Grandpa who shares moments like this in your life. He teaches you to build sandcastles and do "man work"...He indulges your childhood whims, sharing in your delight...And I hope one day, when you're all grown up, that you will think back on your Grampa Pixley and remember a moment like this."

Annette Pixley

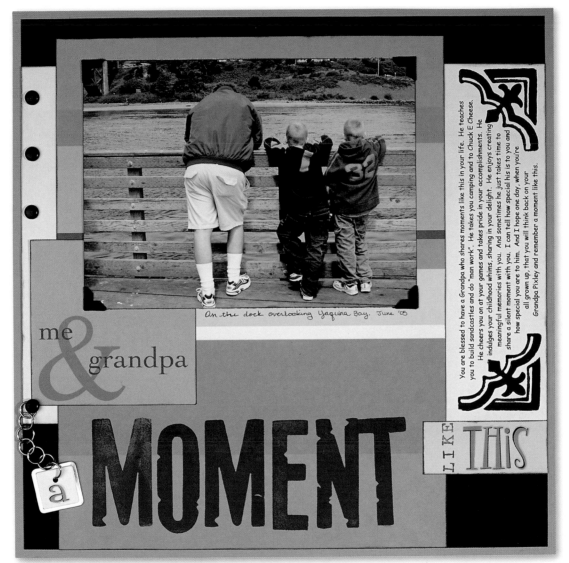

me &grandpa

On the dock overlooking Yaquina Bay. June '05

You are blessed to have a Grandpa who shares moments like this in your life. He teaches you to build sandcastles and do "man work". He takes you camping and to Chuck E Cheese. He cheers you on at your games and takes pride in your accomplishments. He indulges your childhood whims, sharing in your delight. He enjoys creating meaningful memories with you. And sometimes he just takes time to share a silent moment with you. I can tell how special his is to you and how special you are to him. And I hope one day, when you're all grown up, that you will think back on your Grampa Pixley and remember a moment like this.

a MOMENT LIKE THIS

Annette Pixley

A Moment Like This

Moments shared between the generations are rare and very special. This photo, preserving that occasion, is matted on patterned paper and mounted on dark cardstock. A heartfelt journaling block runs vertically up the page. Stamped letters and stickers form the page title and supply additional information.

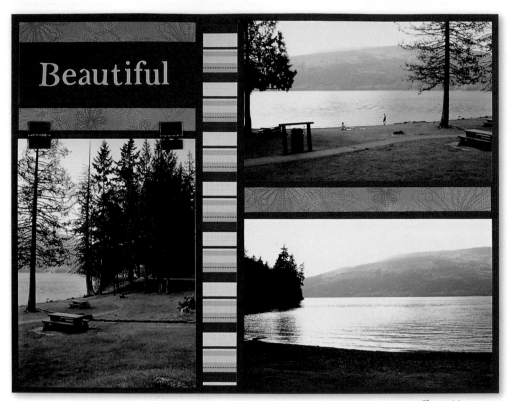

Cherie Nymeyer

"...Many times I would just stare out the car window trying to take it all in...I will forever remember British Columbia in its jaw dropping splendor."

Cherie Nymeyer

Beautiful

When a landscape is too beautiful for words, it is often best to hide your thoughts beneath a hinged flap. A simple and elegant title and a strip of patterned paper is all that is needed to complete the scene.

Nature

A day vacation that involved a hike provided the photo for this lovely page. The black-and-white photo is reprinted on fabric and mounted below the focal photo. A ribbon and flower embellish the page while journaling runs vertically up the side of the photograph.

Make the Most of Your Photos

Construct an elegant and harmonious digital scrapbook page by duplicating a portion of the photograph and using it as a design element. The subtle effect allows the artist to use both the color and black-and-white version of the photograph.

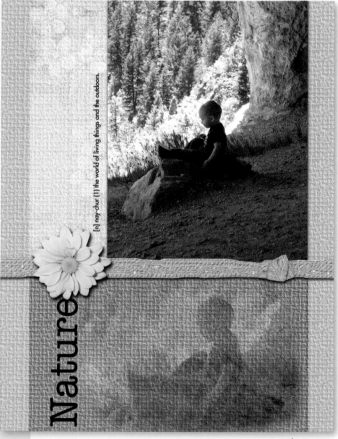

Angela Barton

Silver Falls

The rush of water falls is captured on this interesting layout. A muted palette supports the photos without detracting from the pictures. Rather than cut the photos on the right hand page to accommodate the cropped oval image, the picture is matted and mounted directly over the corners of the other pictures.

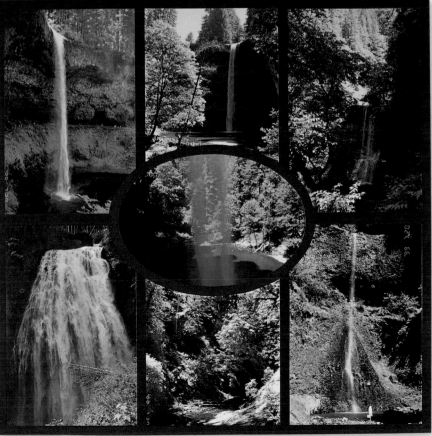

Make the Most of Your Photos

Combining the 7 photographs of the waterfall from various angles becomes even more interesting when arranged in this elegant composition. The page informs the viewer about the place and also creates a fascinating visual texture.

Janneke Smit

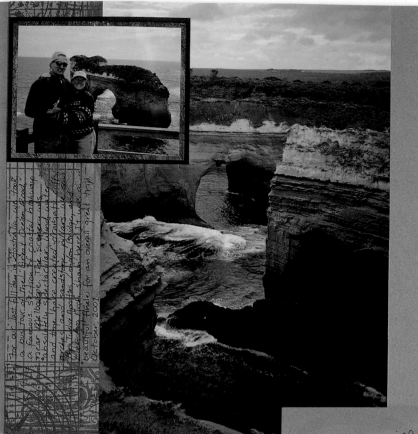

Great Ocean Road

An over-sized photo of a view almost too grand to be real, is featured on this page. The supporting photo is double-matted and mounted across patterned paper and a portion of the focal photo. Journaling runs vertically up the left side of the layout.

Feel the bracing cold wind
Hear the roar of the ocean.
Smell the fresh cool air
Taste the misty salt spray.
See the gorgeous landscape.

Great Ocean Road

Melbourne, Australia 2001

"For our last full day in Australia, we took a bus tour of the "Great Ocean Road," a famous section of coastal highway near Melbourne. The scenery was absolutely spectacular. Wind, water and time have created dramatic cliffs, arches and sandstone pillars..."

Nancy Korf

Nancy Korf

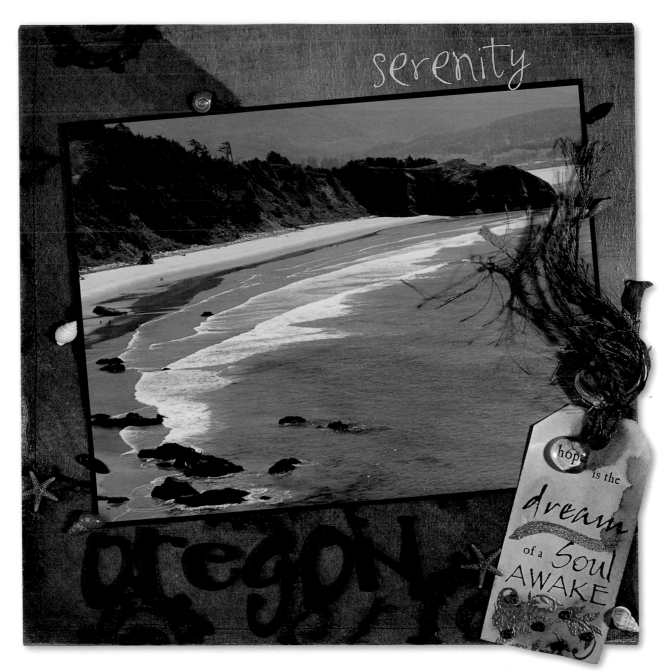

Serenity

This graceful span of beach will be remembered as pure and unsullied forever due to this stunning page. The photo is matted and then mounted on patterned paper which, in turn, has been mounted onto a canvas background. A journaling tag is decorated with fibers and a glass pebble. Sea shells snuggle up to the tag and are scattered across the page.

Tristann Graves

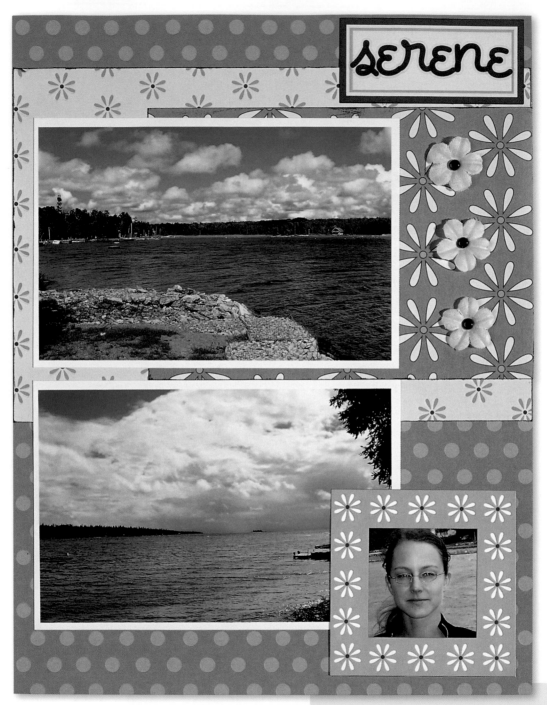

Cherie Nymeyer

Serene

A body of water can sooth the soul. When water isn't to be found, a photo of it can serve the same purpose. These lovely photos are scrapbooked simply on layers of coordinating patterned papers. The title in the upper right corner is neatly balanced by the supporting photo inside the decorative slide mount in the lower right.

Make the Most of Your Photos

Personalize your landscape and travel photos with a self-portrait. Have a friend or a passerby snap a photo of you whenever you travel. This page is transformed from beautiful memento to personal statement with the inclusion of a self-portrait.

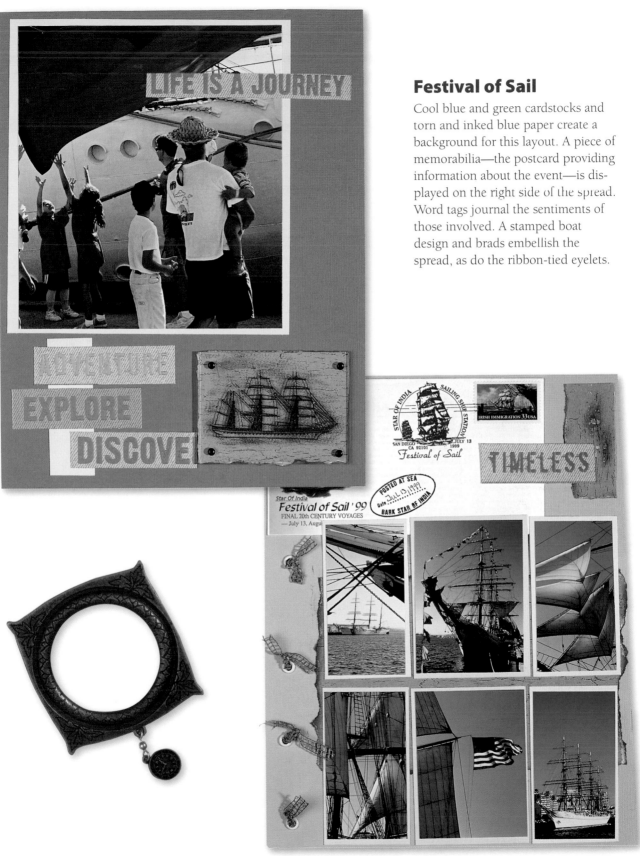

Festival of Sail

Cool blue and green cardstocks and torn and inked blue paper create a background for this layout. A piece of memorabilia—the postcard providing information about the event—is displayed on the right side of the spread. Word tags journal the sentiments of those involved. A stamped boat design and brads embellish the spread, as do the ribbon-tied eyelets.

LIFE IS A JOURNEY

ADVENTURE

EXPLORE

DISCOVE

TIMELESS

Star Of India
Festival of Sail '99
FINAL 20th CENTURY VOYAGES
— July 13, Augu

Festival of Sail

Sue Rhinehart

Safari

The clean green background on this spread houses a focal shot of those enjoying a safari experience and a collection of supporting spectacular wild animal photos. The clever title is printed on frayed fabric. Strips cut from a stained tag are attached to the material with brads and then strung over a twig. Bead embellished tags on the right side of the spread hold fabric-covered slide mounts surrounding tiny photos. The focal photo folds open to reveal an extra photo and journaling.

Heather Dewaelsche

It's Not As Hard As It Looks

The large tag and letter stencils are painted to coordinate with the colors in the photos and the background paper. Blue dye ink is brushed along the left side of the background to allow the silver stencils to "pop."

Nebraska

Miles and miles of open spaces provided plenty of chances for photo-snapping on this road-trip vacation. The photos are scrapbooked on a sky blue background. Minimal embellishing keeps the focus on both the pictures and the extensive journaling block.

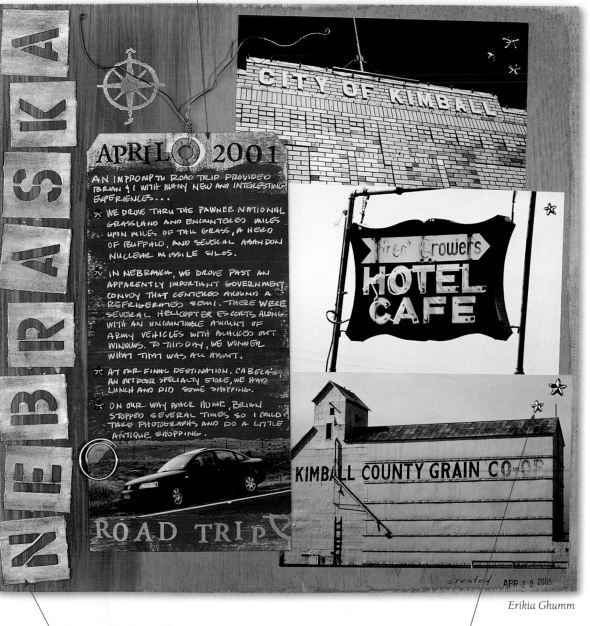

Erikia Ghumm

The stencil title is painted with silver paint and aged with dark gray paint.

Tiny star brads decorate portions of the page, creating visual continuity. The large tag is decorated with stars, a spiral pin and wire.

INDEX